Profitable Portrait
Photography

Roger Berg

AMHERST MEDIA, INC. ■ BUFFALO, NEW YORK

Published by:
Amherst Media, Inc.
P.O. Box 586
Buffalo, NY 14226
Fax: 716-874-4508

Publisher: Craig Alesse
Project Manager: Richard Lynch
Associate Editor: Frances Hagen
Editorial Assistant: Emily Carden

All photos by: Roger Berg

ISBN: 0-936262-65-6
Library of Congress Catalog Card Number: 97-07208

Printed in the United States of America
10 9 8 7 6 5 4 3 2 1

Table of Contents

Introduction

I sold cameras and photo equipment for 25 years before I finally figured out what my customers really wanted. It wasn't equipment, it was good pictures of family and friends. They wanted to remember loved ones, and be remembered. They wanted — and were willing to pay — to look good in pictures. Families treasure beautiful portraits more than simple snapshots. Good creative portraits require more skill than casual snapshots.

In this book, I will show you how to develop the techniques and resources you need to start a profitable portrait photography business. You will learn to choose and use equipment, and how to arrange the lighting, settings and subjects for creative portraits. I will provide information on designing a portrait studio as well as working on location in your subjects' homes and businesses, or in outdoor locations. You will learn how to create the competitive advantage of fast service — even "One Hour Portraits" — with traditional processing methods or digital technology. And finally, you will learn to make your customer your friend and salesperson, and keep them coming to you for portraits.

Photography can be a rewarding business, full or part time. By using the techniques outlined in this book, you will be on your way to creating beautiful portraits your customers will treasure.

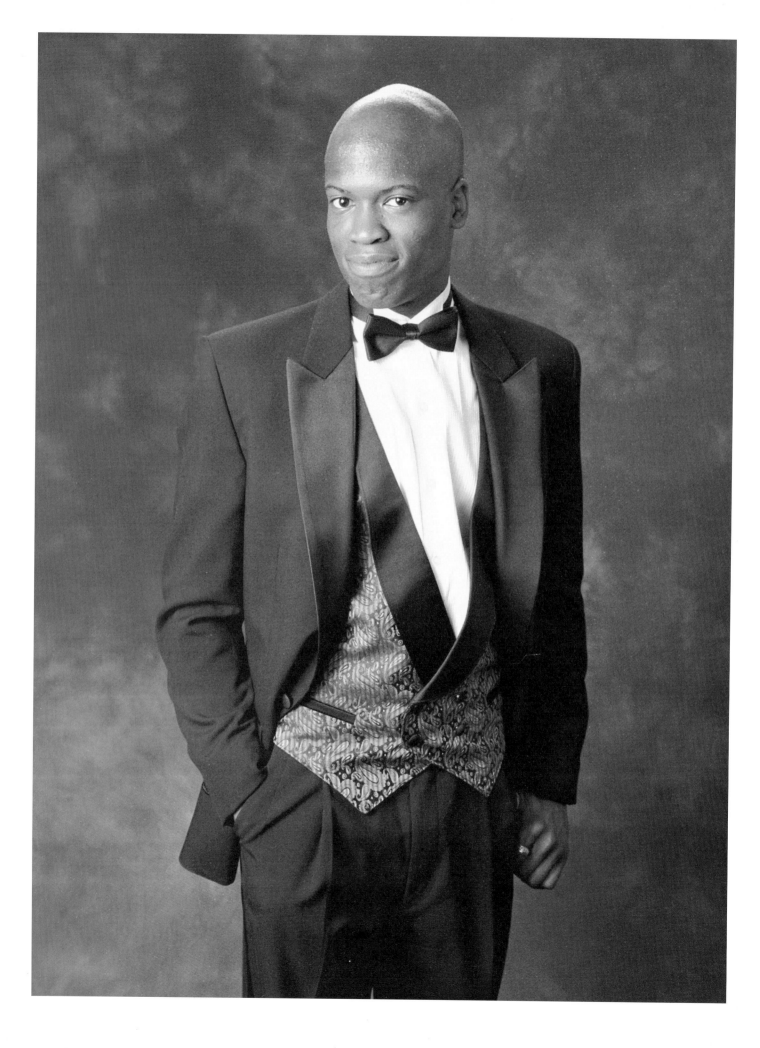

CHAPTER ONE

Equipment Overview

When I decided to become a full time portrait and commercial photographer, I looked to the successful photographers in the business. Most portrait photographers were using 6x6 or 6x7 medium format cameras — often using soft focus lenses because their customers didn't like the sharp images. Many of the medium format photographers using fixed focal length lenses were doing most of their cropping and composition in the lab, often using only a small part of the medium format negative.

Choosing a Format

If we use 35mm the way it was designed to be used (hand held, to capture spontaneous expressions) and crop exactly the way we want the finished picture to look, 35mm is adequate, or even better than the larger formats. 35mm is fast, inexpensive, uses long film rolls, has automatic features, and a variety of lenses are available which allow for exact cropping as you shoot.

This 3/4 standing pose (left) lets us see this high school senior's sharp outfit. Since his demeanor was casual, we kept the pose loose by opening jacket and having him pose with his hand in his pocket. Using a zoom lens allows us to move quickly from tight close-ups, to full body poses.

The primary disadvantage of 35mm has always been that the negative is too small to be retouched. But today, retouching can be done in the computer from digital images, or high resolution scans made from the original negatives or transparencies. Digital retouching makes possible a degree and accuracy of retouching that was never possible with pencils, brushes and dyes. The retouched digital file can be used to make prints directly, or to create a new negative of whatever size is appropriate for the print you wish to make.

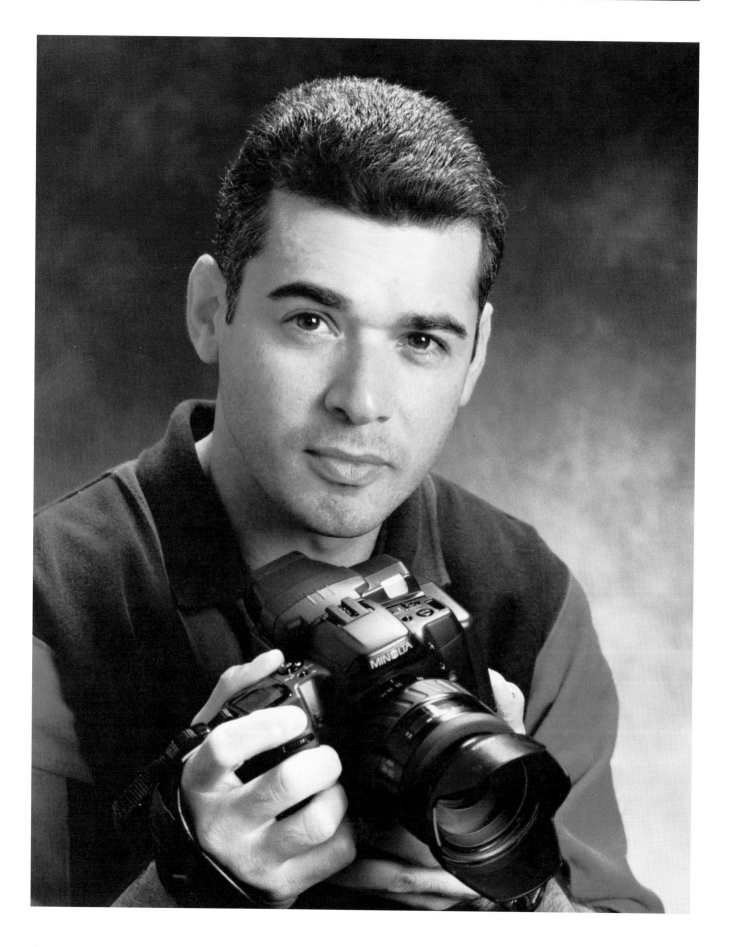

Digital Cameras

One advantage of digital images is that they are ready for the computer — they don't have to be scanned. If the image is to be published or printed on any kind of digital printer, it is ready to go and saves the time and cost of scanning.

The disadvantage of digital cameras is the difficulty of quickly and efficiently showing a large variety of images to a customer for selection. Most digital cameras produce only little preview images in the computer until you "acquire" them into a program (i.e. Adobe Photoshop). This process takes a minute or so per image. If you take many pictures of a customer, it is troublesome to make any kind of inexpensive, fast proof prints. Some digital cameras show each picture on a large monitor as fast as you shoot. This lets the customer select which pictures to save as you shoot.

(left) This portrait shows a Minolta digital camera. Images can print 5"x7" with good quality, and may stretch to 8"x10" in the hands of a good technician.

(right) A high school senior portrait taken with a digital camera.

Generally, a file of 5 to 8 MB size is required to produce an 8"x10" print of reasonable photographic quality. With some computer manipulation, printers can make larger, quality prints. Large wall-size prints require an image file in the 15 to 20 MB range.

Printers

Digital printers employ materials that are costly compared to photo paper. Much of the digital output, while it looks good, does not look like the photograph that the customer expects — unless you enhance the print with lamination and mounting. Dye sublimation printers (which produce high quality prints directly from the computer) are more costly to operate than photographic materials; however, they produce beautiful images and are carefree and easy to use — even on location.

There are several desktop ink jet printers available that print at near photographic quality when used with special photo paper. Prints as large as 8"x10" or even 11"x17" made on these printers are marketable if enhanced with mounting and laminating. These printers are quite slow for high production work, however.

Large format prints (36" or wider, by any length) can be printed directly from your computer on ink jet printers either on paper or on artist's canvas. Since these print with water-soluble inks, they need to be laminated or lacquered for protection.

Film

Traditional film is still the most portable, highest quality capture medium. Professional portrait films made by most film manufacturers are designed to produce the soft gradation of tone needed for flattering portraits. These films are especially designed to produce excellent flesh tones and clear white tones. Often these 160 ISO films are used at a speed of 100 to make a fuller negative density with increased color saturation. Amateur films, however, are usually too contrasty and brilliant in color to be desirable for portraits. With adequate studio lighting equipment, you can easily use films in the 100 or 160 ISO range, and grain is not a problem in print sizes most people purchase.

"These films are especially designed to produce excellent flesh tones..."

Camera Features

Choose from many popular brands of automatic focus, single lens reflex cameras. These offer an array of interchangeable lenses. Fast autofocus is of fundamental importance. Another important feature is the ability to set a customized film speed (for example to allow shooting ISO 160 films at ISO 100). It's also desirable to be able to lock your standard exposure settings; they are easily changed on most cameras and inadvertent changes could lead to exposure errors. While automatic focusing is fast, it does not move as quickly as some young subjects do — autofocus release priority is helpful. This allows you to take the picture when the subject is ready, even if the camera detects a minor focus error.

Zoom Lenses

Zoom lenses allow a photographer to accurately crop the image in the camera viewfinder. This is important since when using a small negative, you have to use every bit of the image area in the film frame. You need a fairly long zoom that focuses close for most portraits. The 28 - 200mm is good, provided that it focuses to about 5 feet for tight close ups. With the kind of studio lighting discussed later, however, expensive high-speed lenses are not necessary.

You also need a wide angle zoom for groups and full-length pictures. I use a 24 - 85mm that allows us to do groups of 6 to 8 people on a 10 feet wide background in a room 15 feet deep. Arrange the group in a shallow way since if everyone is not at the same distance, the people in front will seem disproportionally larger than the ones in the back row. The 28 - 200 auto focus zooms are excellent, but some do not focus close enough without a close-up filter.

Soft focus filters can be held by hand over the lens to easily switch from with, to without.

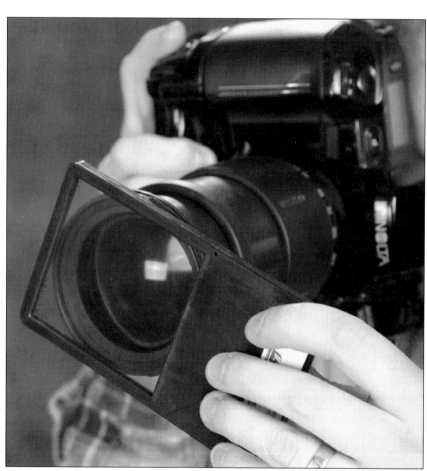

Soft Focus Filters

Sharpness is not a problem with brand name lenses, in fact the problem is that these lenses are too sharp. Soft focus filters are required for many portraits. Photographers like the fine, crisp details, but most subjects don't want to display sharp detail in their faces. I use soft focus filters in two degrees: slightly soft for most portraits, and one with considerable softness when I want to conceal wrinkles or smooth a ruddy facial tone. There are many types of soft filters, and all work differently — so some testing is appropriate. If you don't like soft focus in portraits, you have probably

"There are many types of soft filters, and all work differently..."

12

never seen it done well: cheap soft filters produce poor results and are not an accurate representation of the effect.

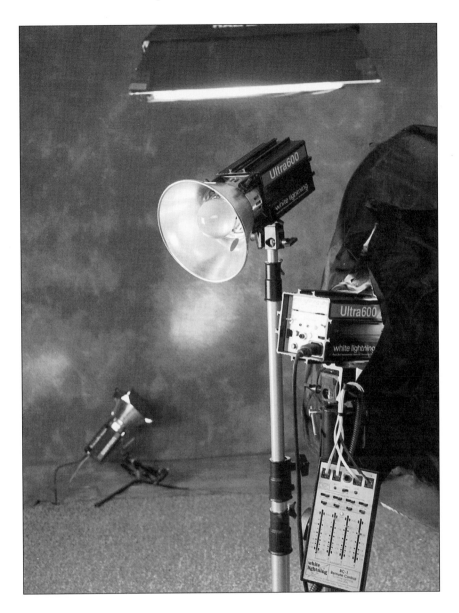

If you use fast strobe lighting for your studio portraits, it becomes impossible to move the camera quickly enough to blur the image. A tripod is cumbersome because it makes it difficult to move quickly and compose the portrait accurately. Therefore, I suggest hand holding the camera and learning to work quickly to capture spontaneous expressions and poses. Your portraits can be accurately cropped and composed in the camera viewfinder by adjusting the zoom lens while you shoot.

CHAPTER TWO

Studio Lighting

L ight is the tool of creative photography. It is a mistake to think of light only in terms of quantity or correct exposure. It is the quality of light that makes a beautiful portrait. Creative photographers sculpt with light and shadows, and it is your job to use light creatively. In order to do this, you need to understand what each light contributes to the finished portrait. When you understand the job of each light, you may find a need for additional lights, or decide to use fewer lights. Normally, your approach will be a four light system.

"The essence of lighting can be broken down into a four light system."

The Four Light System

The essence of lighting can be broken down into a four light system. Understanding how to use these correctly will give you the tools to sculpt images with light. The four lights are:

#1 *The Main Light* determines exposure, the softness of lighting and creates shadows.

#2 *The Fill Light* determines the lighting ratio or how dark the shadows will be.

#3 *The Background Light* controls the background tone and color.

#4 *The Hair Light* helps separate the subject from the background and adds depth to a portrait

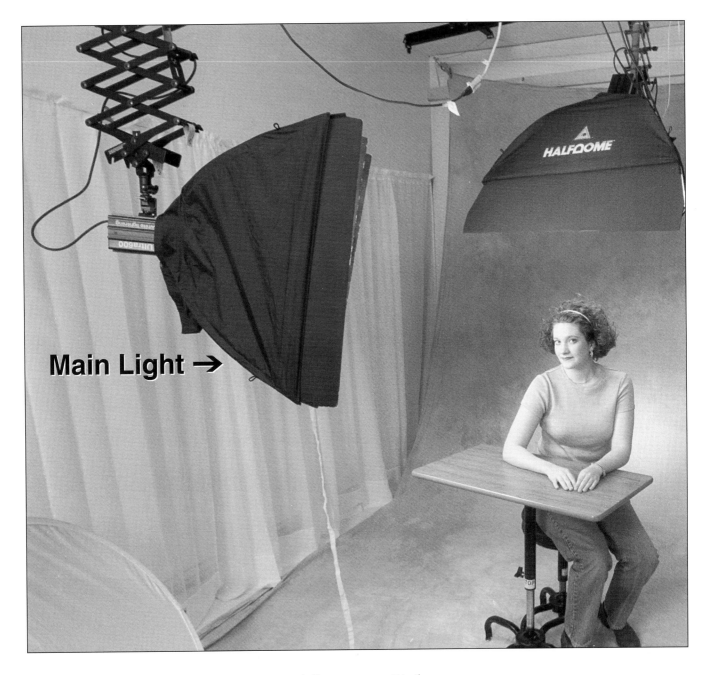

Main Light →

#1 The Main Light

The main light determines exposure and the degree of softness of the lighting. Also, it creates the pattern of light and shadows. Because the main light appears to be the light source in the picture, it is the only one you have to consider for correct exposure. The other lights are all in relation to the main light. (For example, the hair light might be one or two stops brighter, especially for dark-haired subjects. The fill light will always be dimmer than the main light, and the background light can even be turned off.)

"...use a main light that is larger than the subject."

The size of the main light determines the quality or texture of the lighting. A large main light will "wrap around" the subject and produce soft shadows, usually appropriate for portraits A small main light will produce sharp, hard-edged shadows.

I use a 24"x 32" soft box for a main light. Occasionally I switch to a 20" parabolic reflector for more brilliant lighting, or even a 7" spot reflector for very harsh light to illustrate maximum texture.

Large main lights create soft shadows. The larger the light is in relation to the subject, the softer the shadows in the portrait will be. However, a small light close up might be photographically large. Even a large light becomes small relative to the subject if it is moved back far enough. Your goal is to position a large light close enough that it wraps light around the subject, illuminating its own shadows for a soft, flattering effect.

Generally use a main light that is larger than the subject. Keep the size of the soft boxes or umbrellas in relation to the size of the subject. I recommend using a 24" x 32" soft box for the main light, close up, to illuminate the face and create soft, flattering shadows.

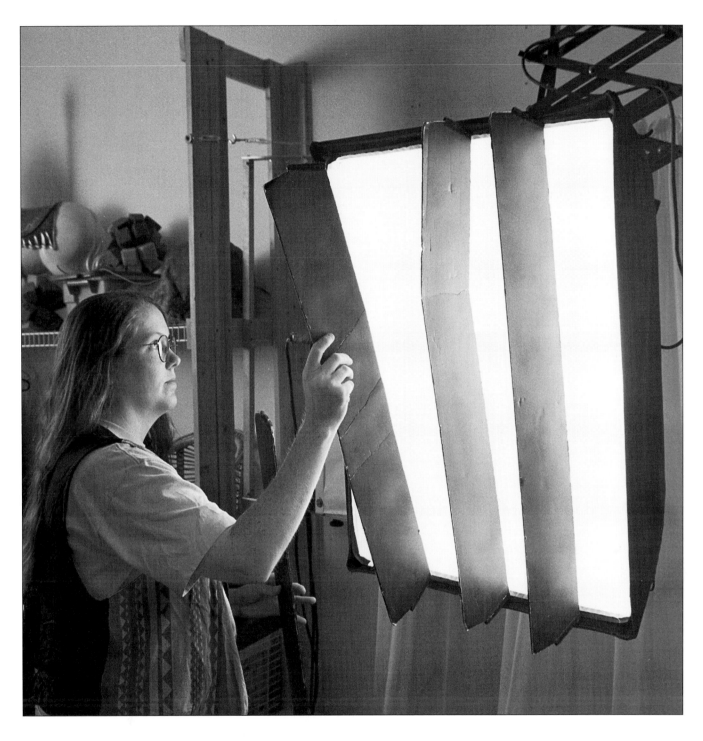

Soft lights tend to spill excess light all over the camera room. To control this spill effect, you can make louvers out of black foam core board (about 4" wide and as tall as your light) and attach them to the front of the soft boxes with velcro tabs. Place them in front of the light, spaced about 4" to 5" apart. They give the light more direction and keep it from unnecessarily illuminating the background or other areas of the studio.

Adjust the height of main light. Height or elevation of the main light is critical to producing attractive light patterns. The light is too high if you do not get "catch lights" — reflections of the main light in both of the subject's eyes. The light is too low if you do not have a shadow under the subject's nose. Simply study the arrangement of the light and shadow patterns on the subject's face to determine the proper height of the main light.

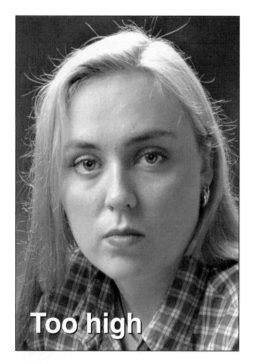

Too high

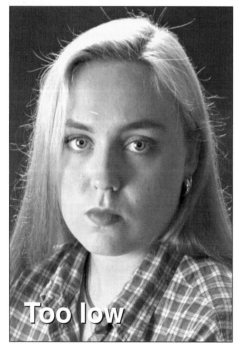

Too low

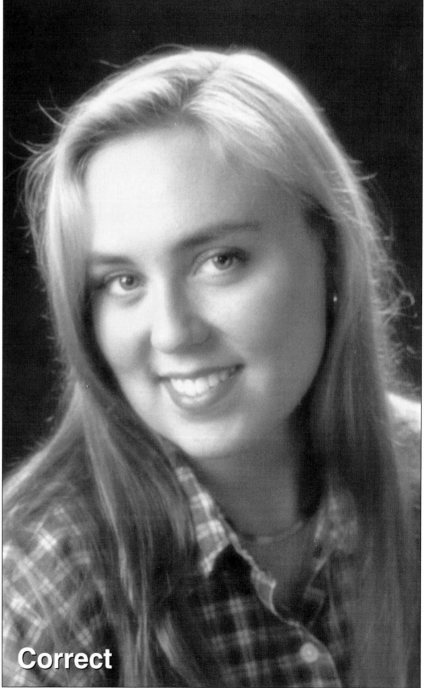

Correct

Even with the main light in the correct place, turning your subject's head sharply or using a reclining pose with the head on folded arms might cause the light to shine up the subject's nostrils. This occurs when the light is too low. You might end up with dark eyes from a light that is too high. Avoid these pitfalls by carefully arranging your subject and your lights.

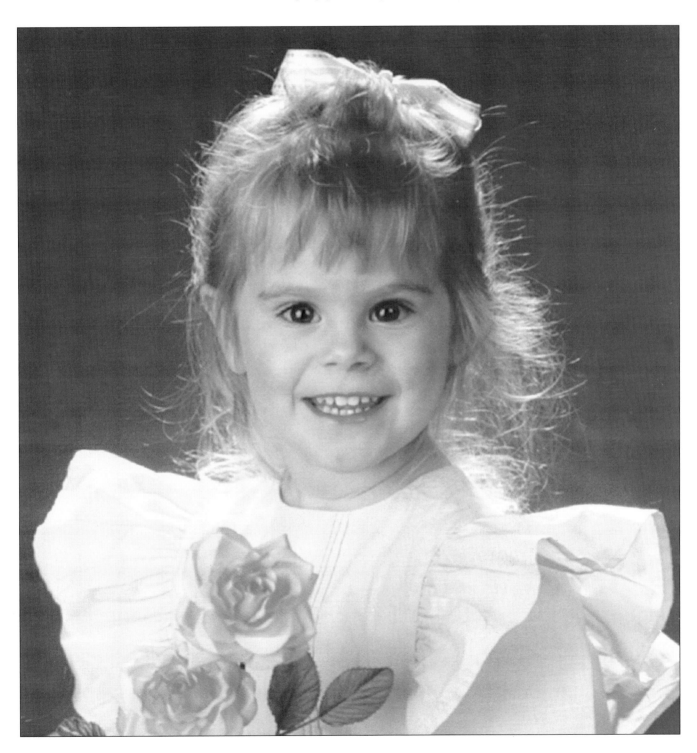

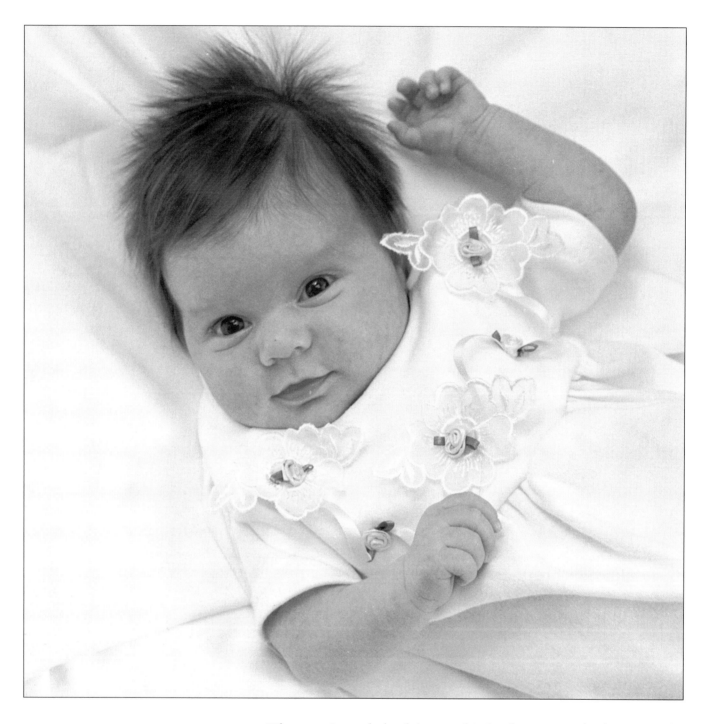

When posing a baby lying on his back, you are looking straight down at him. Place the light to create a shadow under his nose and catch lights in both eyes.

Exposure is critical. I always shoot at *f*8 in the studio to keep the light intensity the same on every subject's face. The shutter is set to a medium speed (1/125th). The main light is adjusted for a consistent intensity, measured with an incident strobe meter.

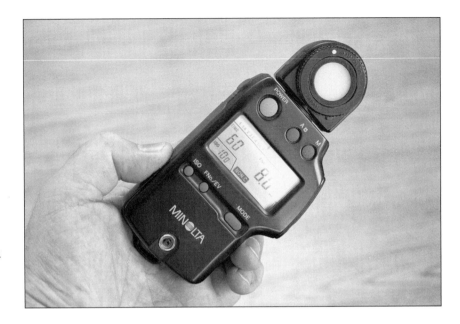

An incident meter measures the intensity of the light striking the sensor. It is held near the subject and pointed toward the light source being measured.

Use an incident light strobe meter. Read the intensity of the main light with an an incident light strobe meter. For this reading, all other lights should be approximately at the correct setting, or at least less intense than the main light.

Hold the meter at the subject's face and point it toward the main light, with all the lights on. Fire the lights and check the meter. Change the intensity of the main light to get a reading of exactly *f*8. The exposure will now remain correct for *f*8 if you keep the light at this same distance. Use a string to keep the distance of the main light consistent and accurate for each new pose.

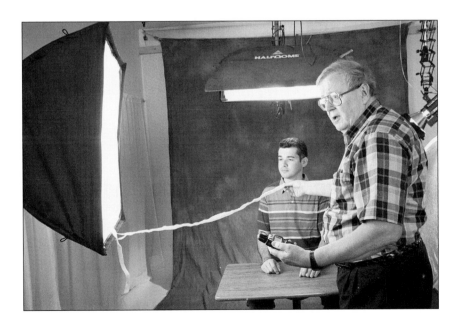

A string attached to the main light will keep the distance from the main light the same. Consistent distance will make consistent exposures.

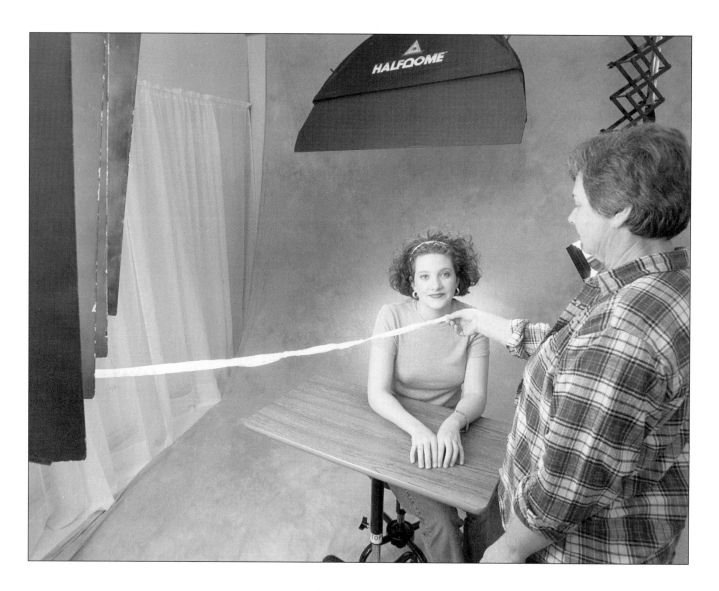

For each new set-up, position your main light at the appropriate distance from the subject: 3 or 4 feet for individual portraits, farther back for full-length poses or groups. Set the string to this distance and take a reading with an incident reading flash meter. Since lights are adjustable in intensity, adjust the light for exactly f8 exposure at the distance of the string. Re-check the meter and string once with each set-up change.

Use this method for both white-on-white and black-on-black pictures. For dark-skinned subjects, use the same exposure and string distance as you would for light-skinned subjects — individually or within the same picture. Every negative should produce a print that is a good interpretation of how a subject looked: dark should be dark and light should be light. Consistent light intensity and consistent exposure make this happen.

In dark (left) or light (below) portraits, maintain illumination on the face of the subject. This is accomplished with proper placement and consistent intensity of the main light.

#2 The Fill Light

The fill light determines the lighting ratio: the darkness of the shadows. Its purpose is to illuminate existing shadows, not create new ones. It should be as large as practical, and as close to the lens (and just above the lens) as possible. Bouncing the fill light off the wall or a large soft reflector behind and slightly higher than the photographer works well. The fill light in my studio reflects off of the entire wall behind the photographer, creating a circle of light on the wall.

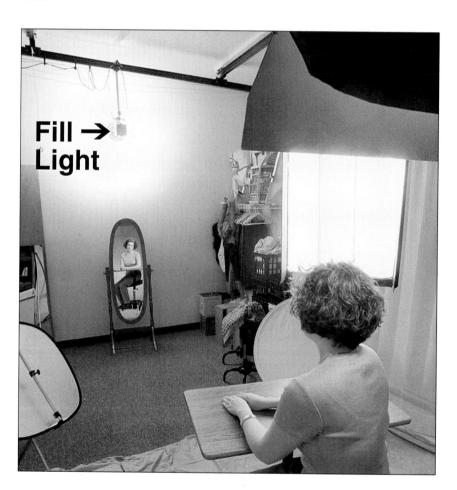

Fill →
Light

"...the fill will always be dimmer than the main light."

Arrange the light so that it creates a spot of light about 6 feet in diameter. As an alternative you could use a large light source above and behind the photographer. Be sure to avoid anything that might shine, like a silver reflector — just a plain white painted wall is excellent. Not much intensity is needed since the fill will always be dimmer than the main light. Keep it as shadowless as possible. Remember, this light is only supposed to slightly illuminate the shadows created by the main light.

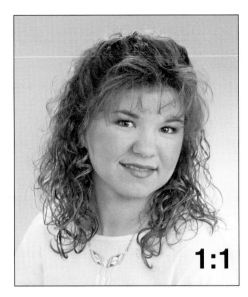

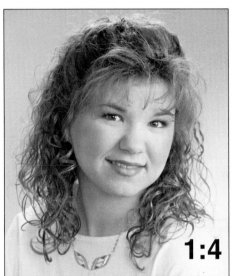

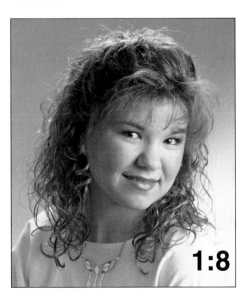

Determine the lighting ratio. Lighting ratio is simple. A fill light half as bright as the main light creates a 1:2 ratio. A 1:8 ratio means that the fill light is 1/8 as bright as the main light. Each *f*-stop is double or half the amount of light of the next *f*-stop. This creates the following ratios:

- 1 stop = 1/2
- 2 stops = 1/4
- 3 stops = 1/8

A ratio of 1:2 is so slight that you can hardly see the shadow pattern. A ratio of 1:1 means that the main and fill light have the same intensity. An 1:8 ratio produces dramatic, dark shadows.

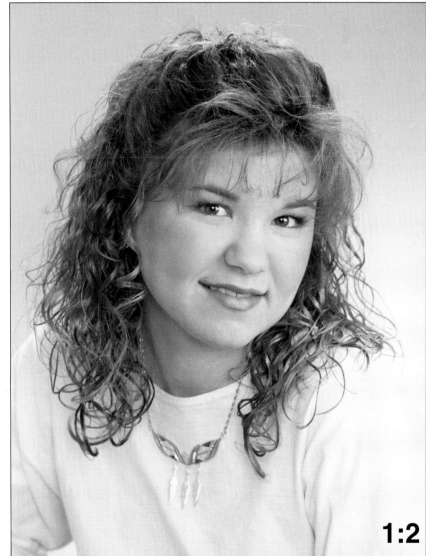

Proportional modeling lights. Proportional modeling lights show an accurate representation of how an image will photograph. The light of the flash is exactly proportional to the brightness of the modeling light. When you adjust the intensity of the flash, the intensity of the modeling light automatically adjusts. In other words, what you see through the lens is what you get in the print. With proportional modeling lights, set the brightness of the main light for correct exposure. Then with no other lights in the camera room, visually adjust the brightness of the fill light. When you take the picture, it will look just like what you saw while setting up the shot. Most professional flash equipment has proportional modeling lights.

"You may tweak these lights ... visually, from the camera position."

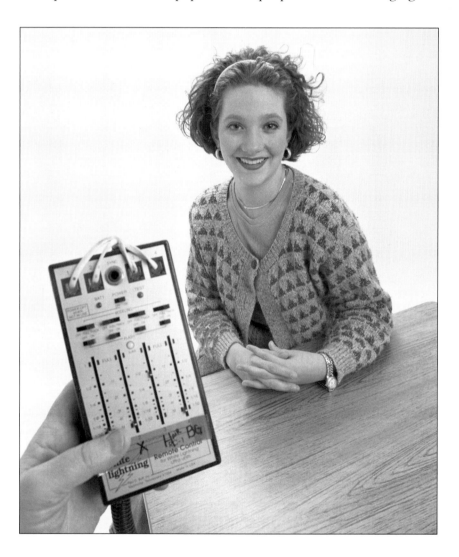

Remote control allows you to adjust all the controls of all the lights — from the camera position. You may tweak these lights as you shoot, changing the fill ratio, the background brightness or the hair light, all visually, from the camera position.

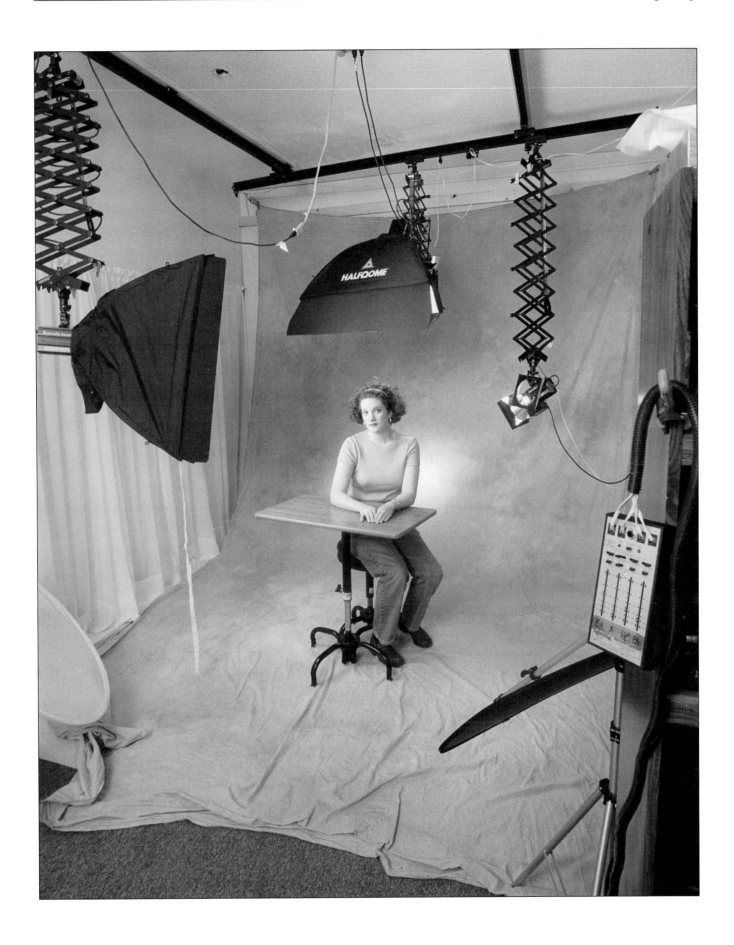

Do not hook up the main light to the remote. The main light is easy to adjust manually (and too easy to misadjust from the remote control). Simply set the main light with a meter and a string each time you set up the camera room. Shoot an entire sitting by checking the exposure quickly with the string. The other lights are all adjusted visually. Simply look at the lighting patterns and intensity of the shadows on the subject's face. There should be no other light in the room, except the modeling lights.

The modeling light also tells when your flash is ready. On most flash units the flash is ready when the modeling light comes back on. Since you don't want the subject to be left sitting in the dark while the lights recycle, set the main and fill lights so the modeling light does not go off. Have the background and hair lights set so the modeling light comes on when the flash is ready.

Reflectors make great fill lights. Use an adjustable stand for the reflector: you cannot hold both a reflector and a camera. Some photographers use reflectors as the only fill, but we use a fill light and add reflectors to provide illumination from below or other angles. The reflectors gently wrap the lighting around the subject.

"The reflectors gently wrap the lighting around the subject."

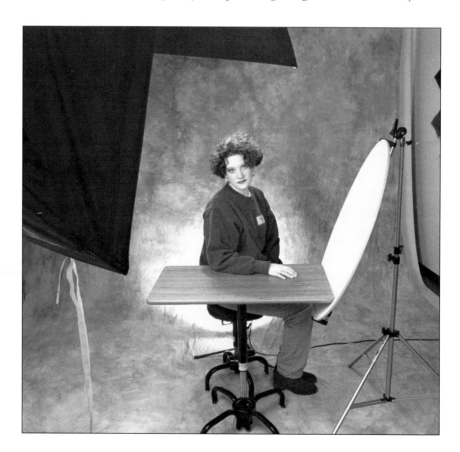

To achieve maximum control in fill lighting, you might use a reflector with one silver side and the other side painted a flat white. Another option is white on one side, black on the other. Fill light bounced off a reflector is bright, flattering, and shadowless.

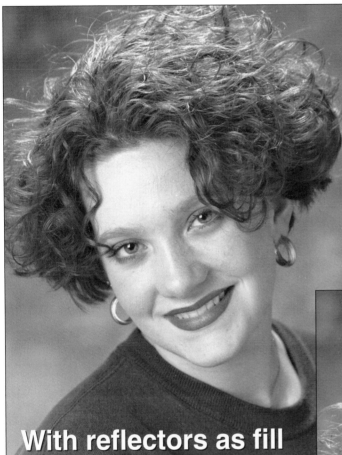

With reflectors as fill

Without reflector fill

#3 The Background Light

The background light controls the tone and color of the background. Our background light is a 7" reflector with various honeycomb grids to vary the angle of light and the size of the illuminated spot on the background.

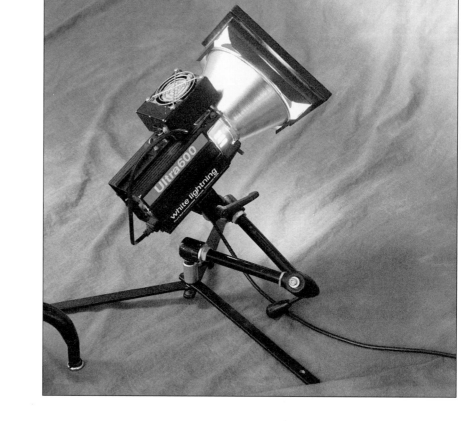

"Skillful use of the background light allows you to produce unlimited effects with less equipment."

Creatively lighting a few different backgrounds is simpler and less expensive than purchasing and storing dozens of painted backgrounds. Skillful use of the background light allows you to produce unlimited effects with less equipment.

To control the background light, you need to control the other lights by keeping them from spilling all over the background. Keep the background 4 to 6 feet behind the subject. This provides flexibility in how this background is lit.

The background light can be on a low stand, hidden behind the subject, or placed on a high stand just outside the camera view on one side. Then throw a spot of light onto the background behind the subject to create a nice "glow" in the background.

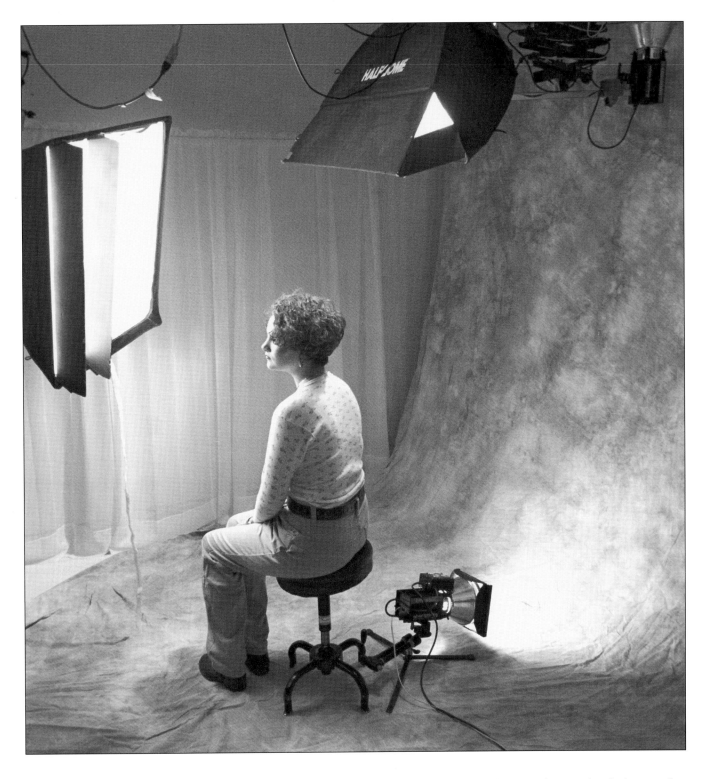

For general illumination of the background, put the light on the floor just behind the subject. Aim the reflector down slightly so that the spot of light falls off at the subject's shoulder height when viewed from the camera position. Generally, do not light the background behind the subject's head. Light the hair instead.

The background light is frequently used at high power — especially if you are trying to make a bright spot on a dark background. Be careful that your subject doesn't get too close to it and get a burn! Some background lights have a fan cooling unit that mounts on top of this light. This is a wise investment; it keeps the light cooler and avoids the cost of repairing an overheated light.

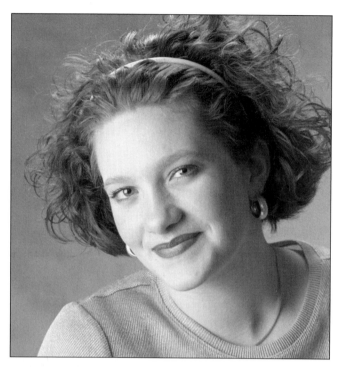

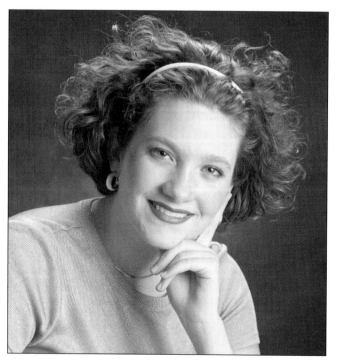 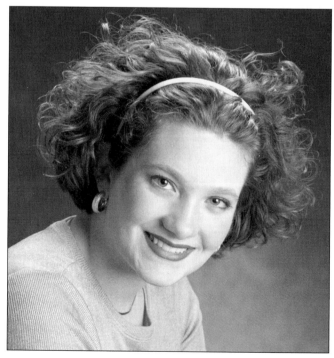

Varying the intensity and placement of background light contributes subtle but interesting differences in portraits.

Honeycomb grids. Honeycomb grids make spot lights out of your regular light units. The grids come in various angles, including 10°, 20°, 30°, or 40° angles.

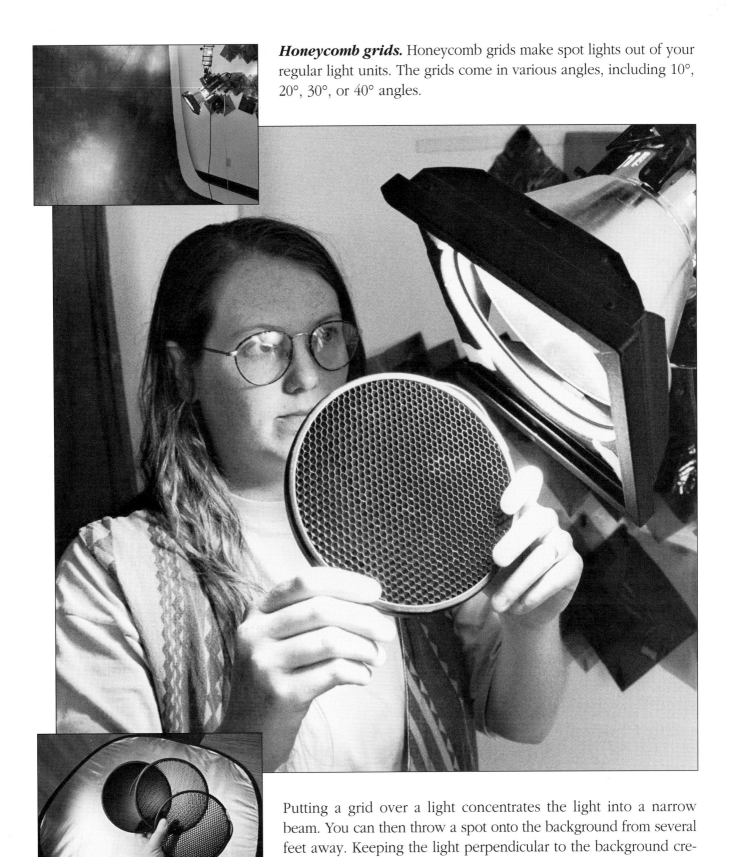

Putting a grid over a light concentrates the light into a narrow beam. You can then throw a spot onto the background from several feet away. Keeping the light perpendicular to the background creates a circular spot, while skimming the spot across the background causes a streak of light or color on the background.

Colored gel filters. Gel filters are an inexpensive creative tool. They come in hundreds of colors, generally in large sheets or rolls. You should have a variety of colors in 7" or 8" squares. Normally use them only on the small reflectors on background lights. Fasten them with velcro, tape, or clips. I prefer using metal filter holders to hold all kinds of accessories on the front of light reflectors. Fit them loosely, so air can circulate and the filters don't burn or melt.

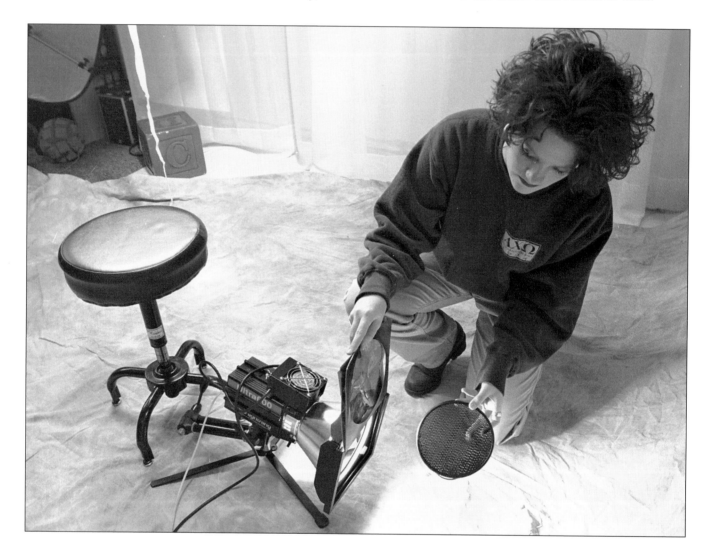

Generally, the gel colors will be more intense when used on a dark background. On a white background, enough spill is picked up from the other lights to keep the colors more pastel. Because they tend to modify the color of the subject's garments, gel filters allow you to match the background with the subject's clothing. Choose colors that complement or match the subject's clothing. Flooding the background with matching colored light creates a striking "color key" portrait.

#4 The Hair Light

The hair light is used to separate and create depth between the subject and the background by making a rim of brighter light on the top edges of the hair and shoulders. Our hair light is a narrow strip soft box, 12"x30", with a large louver (shield) on the front to keep it from shining into the camera lens.

Place the hair light above and behind the subject. A ceiling mount, as pictured left and below, saves the trouble of having to deal with stands, booms, or other clutter. Angle and placement adjustments are easy, and lights and fixtures remain secure. Intensity can be adjusted by remote control.

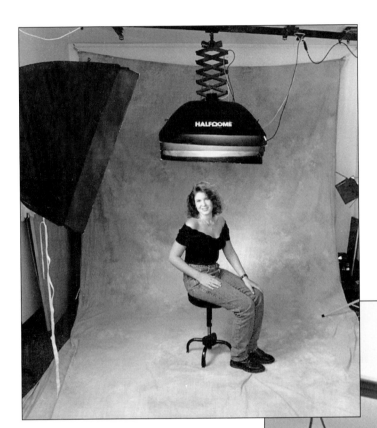

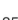

Mount the hair light from the ceiling so it is movable. (In fact, there is a good case for mounting all of your lights on a movable ceiling rail system.) It may be mounted on an adjustable wall or ceiling boom arm, or mounted on a light stand hidden behind the backdrop cloth. It needs to be adjusted in intensity for different hair colors, tones, and styles, which is convenient with remote control.

Try using a wide, thin light fixture — a strip light like the small half dome soft box. A fan-shaped pattern of light illuminates several people in a group with one light. Put this above and behind the subjects as your ceiling allows.

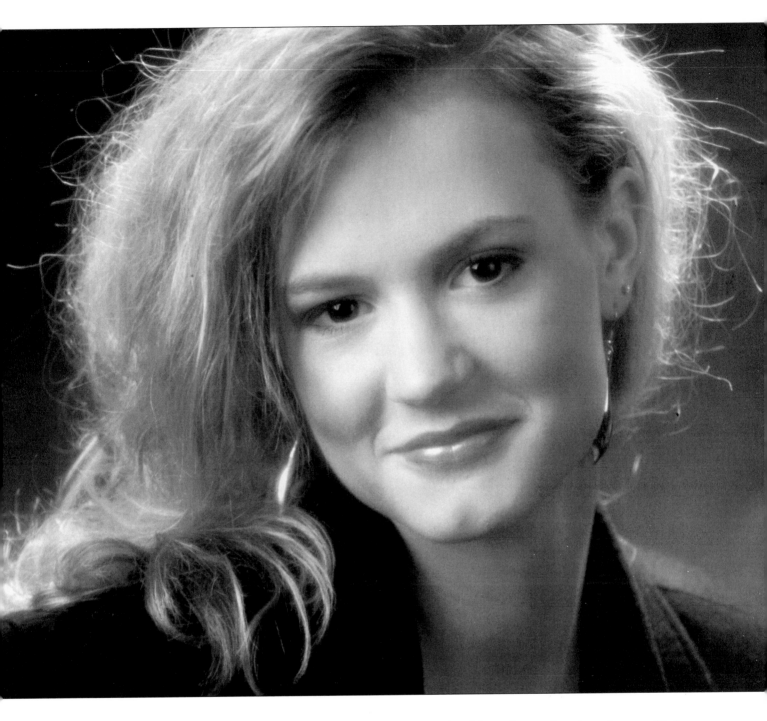

Point the light at the back of the subject's head at about a 45 degree angle. It must have a shade so it does not shine into your camera lens. Adjust it visually; a meter does no good since you need different effects for various hair colors and styles.

For blonde or "bouffant" hair styles, move the light down and back so it shines through the hair rather than on the hair. For dense and dark hair, move the light more overhead.

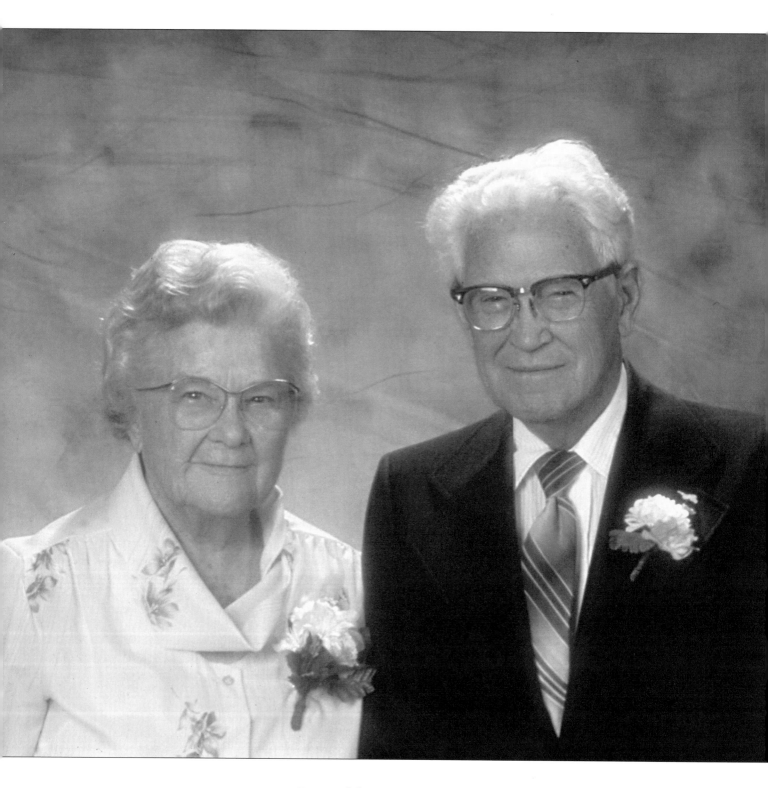

Be careful not to use too much hair light on gray hair or bald heads. Use either no hair light (or just a little intensity) and keep the light low and behind the head. This creates a flattering, tiny rim of light. With white backgrounds, use very little intensity on the hair so it doesn't get lost in the bright background.

In these examples of hair light intensity on dark hair, consider the lack of detail or "sparkle" in the picture with no hair light. Even a slight amount of hair light is a major improvement. Be careful to not use this light so bright that it washes out detail in the hair.

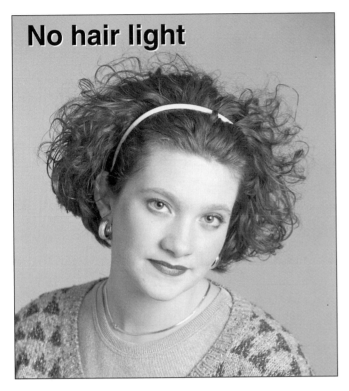

No hair light

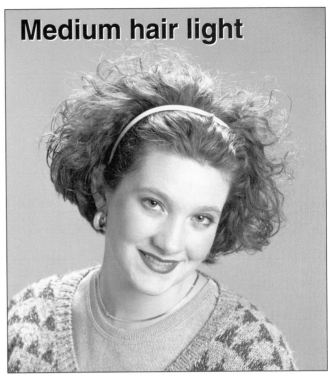

Medium hair light

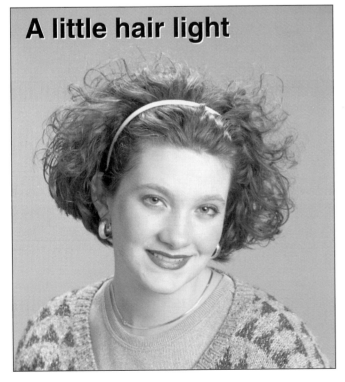

A little hair light

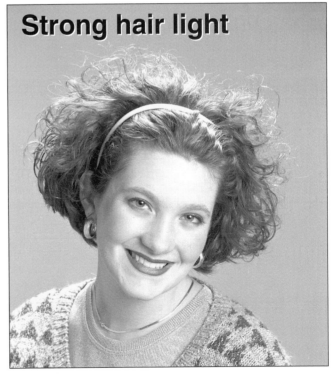

Strong hair light

Equipment and Accessories

You should have tall sturdy light stands, with castors. Also get a low background stand and a short extension pole for it, to keep the background light low and hidden behind the subject.

"You should have tall sturdy light stands, with castors."

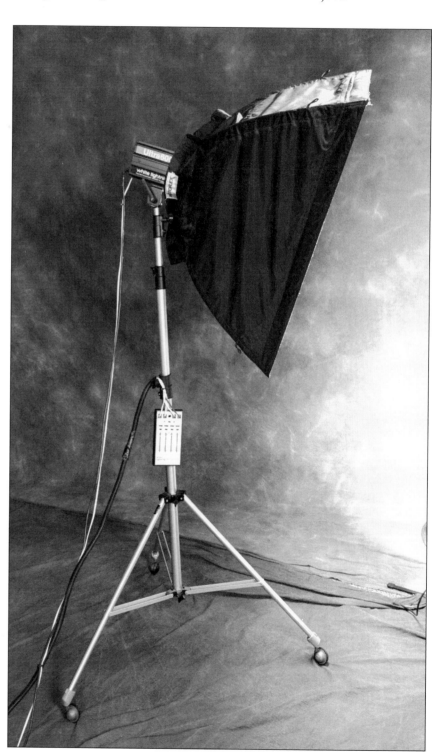

Rail Lighting

If you can, mount your lights from the ceiling on a rail lighting system. As an alternative, you might use a wall boom for the hair light. This will have to be mounted from the wall or ceiling to pivot over the subject. This puts lights up out of the way and eliminates the stands and boom arms.

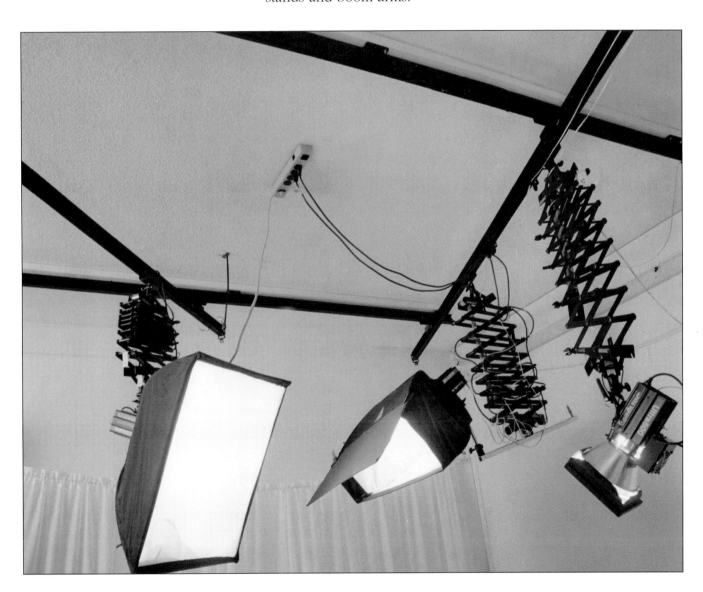

Soft Boxes

You will need a medium sized soft box for the main light. Try bouncing the fill light off the wall or any large reflector behind the photographer. A small strip soft box for the hair light works well. Don't forget strobe adapters for whatever brand soft boxes you use.

Reflectors

Small reflectors come with most light units. Use only one of these on the background light with honeycomb grid and barn doors. These small reflectors can also be used with umbrellas. We use umbrellas on location because they fold quickly and have nearly the same lighting quality as the soft boxes we prefer in the studio.

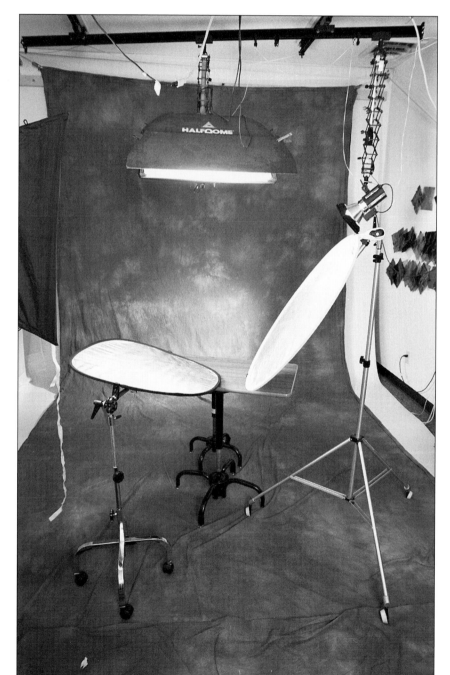

Reflectors placed in front of and below the subject help fill shadows and surround the subject with light. Gobos (black screen below) block unwanted light from reaching the subject, or act as a shield for the camera lens.

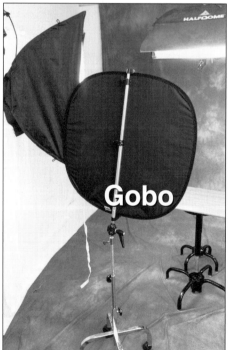

Gobo

Lighting Patterns

Now that you understand main, fill, background and hair lights, and the equipment necessary to modify them, you can combine techniques to create various lighting patterns. Interesting, flattering patterns of light and shadow are the basis of creative portrait lighting. It's simple: the patterns are created by the position of the main light in relation to the position of the subject's face. Rather than discuss where the lights go, I recommend simply looking at the position of the highlights and shadow patterns on the subject's face.

These guidelines will help you create beautiful lighting:

1. See a reflection (a "catch light") of the main light in both of the subject's eyes.

2. The shadow of the nose should go down somewhat, with the underside of the nose in shadow.

3. In most situations, a shadow should be on the near side of the nose.

These simple rules apply to a subject in just about any pose.

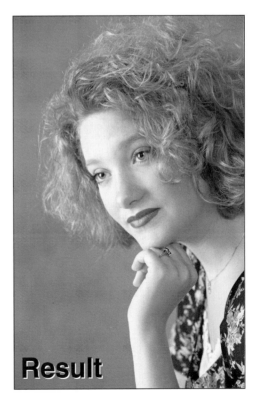

It's easy to achieve three dimensional lighting if you only think of moving one light: the main light. Create effects by moving either the light or the subject. Tilting the subject's head down is the same as moving the light up.

Flat Lighting

Because this pattern doesn't produce any shadows, it is uniform and flat. This might be appropriate when you are learning portrait lighting skills. We use this lighting for groups (everyone gets nice, even lighting with no shadows). We also use it for babies and children who don't follow precise posing instructions.

"...this pattern doesn't produce any shadows, it is uniform and flat."

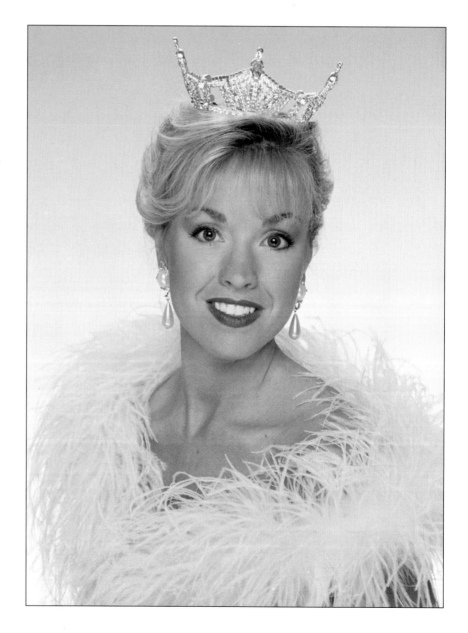

Flat lighting avoids shadows that might infringe on a picture (left), and is excellent for group shots (below).

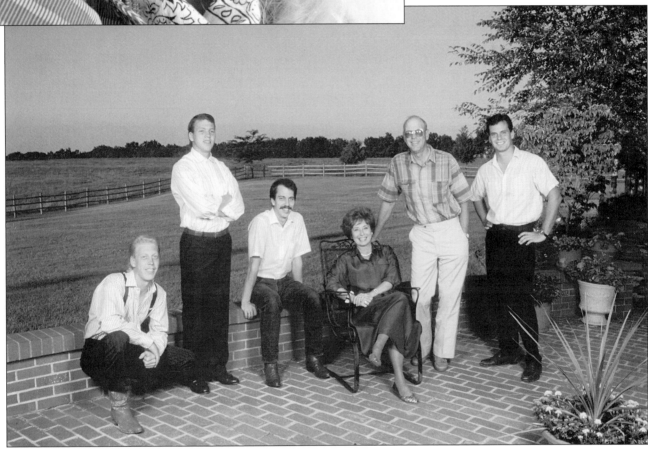

Flat lighting is desirable for fill light in the studio because it illuminates the shadows and does not create any secondary shadows. The only problem with flat lighting is that it is flat: it does not create shadows to define the shapes of the face. The trick is to make the existing shadows define beautiful shapes in faces. The shadows must not be dark or obscure or exaggerate features.

Butterfly Lighting

This pattern is named for the shape of the nose shadow when the main light is placed directly above the lens.

Look at the shadow cast by the nose in the picture below. The large main light is placed right above the camera lens. The light shines straight down on the subject's nose. Notice how the lighting deepens slightly on the cheeks and chin. A natural fall-off in light intensity is created with distance, and gently defines the shape of the face.

Moving the main light to either side will increase shadows and create a different lighting pattern with more shadows.

"...light intensity is created with distance, and gently defines the shape of the face."

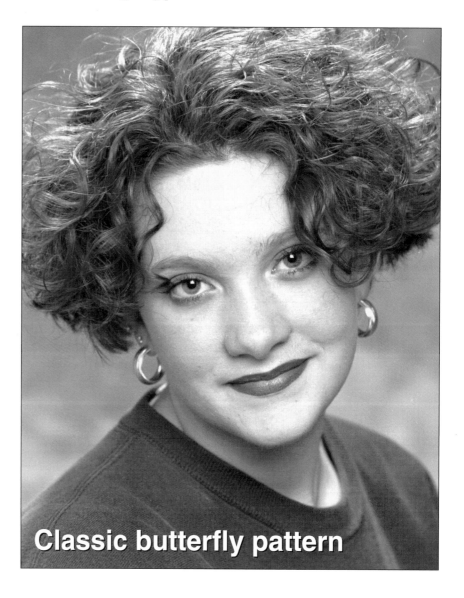

Classic butterfly pattern

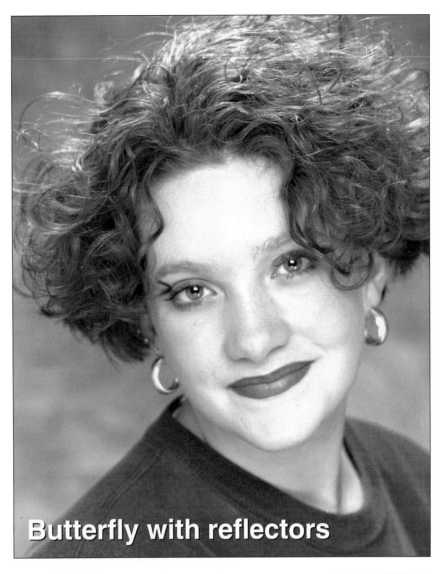

Butterfly with reflectors

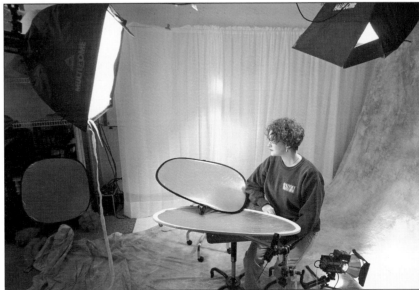

(above right) A butterfly pattern can be softened with wrap around reflectors. It is very flattering lighting, often used in glamour portraits.

(right) The set-up at right shows placement of lights and reflectors to achieve the results above.

"Nearly everyone looks best with this pattern, if it is done well."

Short Lighting

Short light is the "normal" portrait lighting pattern. Nearly everyone looks best with this pattern, if it is done well. There are large areas of shadow, giving a three dimensional appearance to the picture.

If the subject is facing either side, move the light to the side the subject is facing. Moving the light far enough creates a shadow on the side of the nose that is near the camera. The far side of the face then receives the primary light. The triangular highlight on the near cheek defines "high cheekbones" — even if the subject doesn't have them. (This is sometimes called "Rembrandt" lighting.) Short light illuminates the face from behind, which has a great "slimming" effect.

Broad Lighting

This pattern is the opposite of short lighting. Here the broad side of the subject's face, nearest the camera, is fully illuminated, and the far side of the face is in shadow. The effect makes a narrow face wider, but most people don't want to look wider.

Broad lighting is a common photographer's mistake: perhaps the pose was changed without moving the lights, or the lighting was set up from a diagram and the subject was posed without consideration of the facial light pattern produced.

If the light were moved to the camera's left, or if the model turned her head toward the light more, this could become short lighting.

High-Key Portraits

High-key portraits (with all white backgrounds often with subjects dressed in white or light clothing) are easily created by bouncing a light off a white ceiling. Adjust the brightness to achieve a meter reading of $f11$ (1 stops brighter than camera exposure) when you hold the meter on the background behind the subject's head. Shine your background light at the background with a wide 40 degree grid behind your subject and adjust it for $f16$. This gives a background that is pure white. You might set these lights about 1/2 to 1 stop darker to produce a barely perceptible gray tone. This lets some white highlights in the subject's clothing be brighter than the white background.

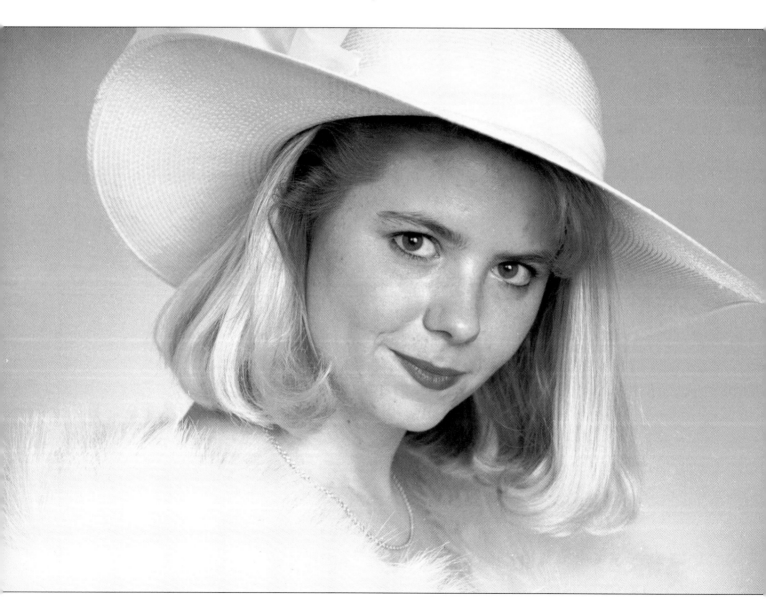

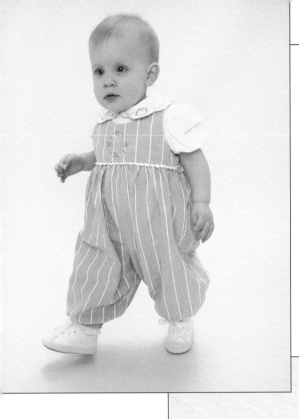

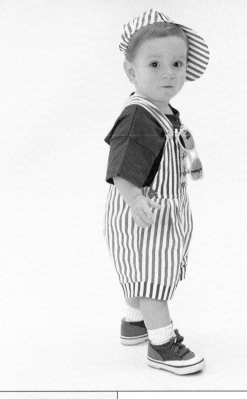

By illuminating for hi-key photos, children can roam around, and we can capture cute, spontaneous action with a fast zoom lens and autofocus.

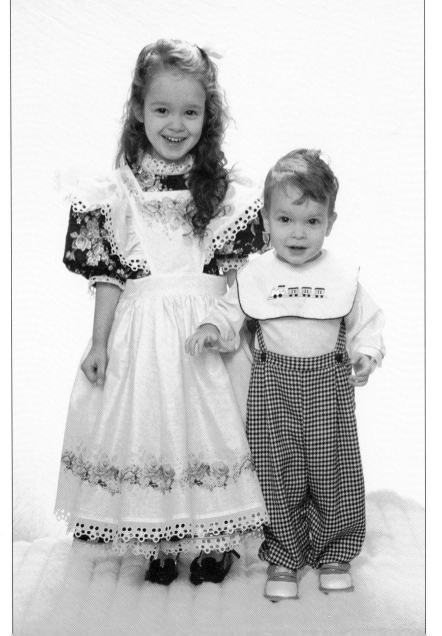

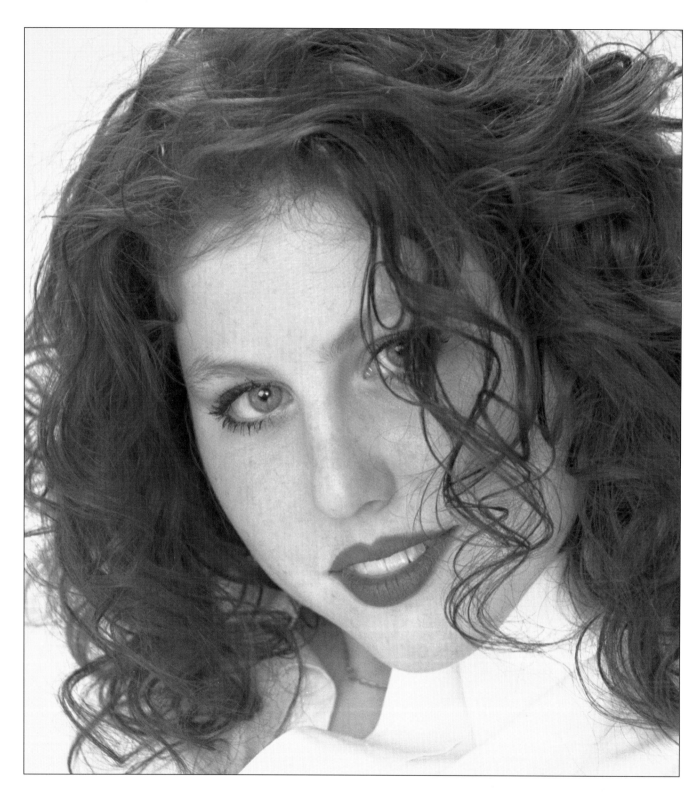

Set the main light for the usual $f8$ and the fill light fairly bright ($f5.6$ for a 1:2 maximum ratio). This is a good situation for flat lighting or butterfly lighting. It's also effective for very fair subjects, blondes, babies, or a mother and baby.

Lighting Variety

Variety in your portraits is good for your creative skills as well as your business. Every subject is different and deserves a fresh approach. Here are two approaches to the classic "mother and child."

These two portraits received exactly the same exposure. The difference was the background and how it was lit, and the amount of fill light used. Each was exposed with the light set at the distance and intensity that gave an *f*8 meter reading at the subject's face.

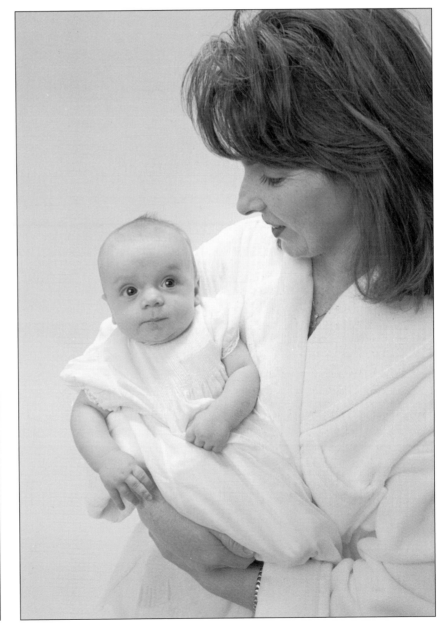

Reflections from Eyeglasses

To avoid eyeglass reflections, try tilting the subject's face down slightly. The subject will open her eyes as she looks up at the camera. Tilt the glasses forward by raising the ear pieces above the ears. You can raise the main light to move the reflections off the lens, but that often results in poor lighting on the lower face. If you raise the light too high, you lose the catch light in the eyes and the lighting will be a failure. You might remove the lenses from their frames as a last resort.

Eyeglass lenses can cause unwanted distortion and may reflect lighting. This detracts from portraits. Careful adjustment of the angle of the glasses can eliminate the problem (opposite page). Digital retouching is another option. The difficult reflection problem shown on this page could only be solved by removing the lenses or by computer retouching.

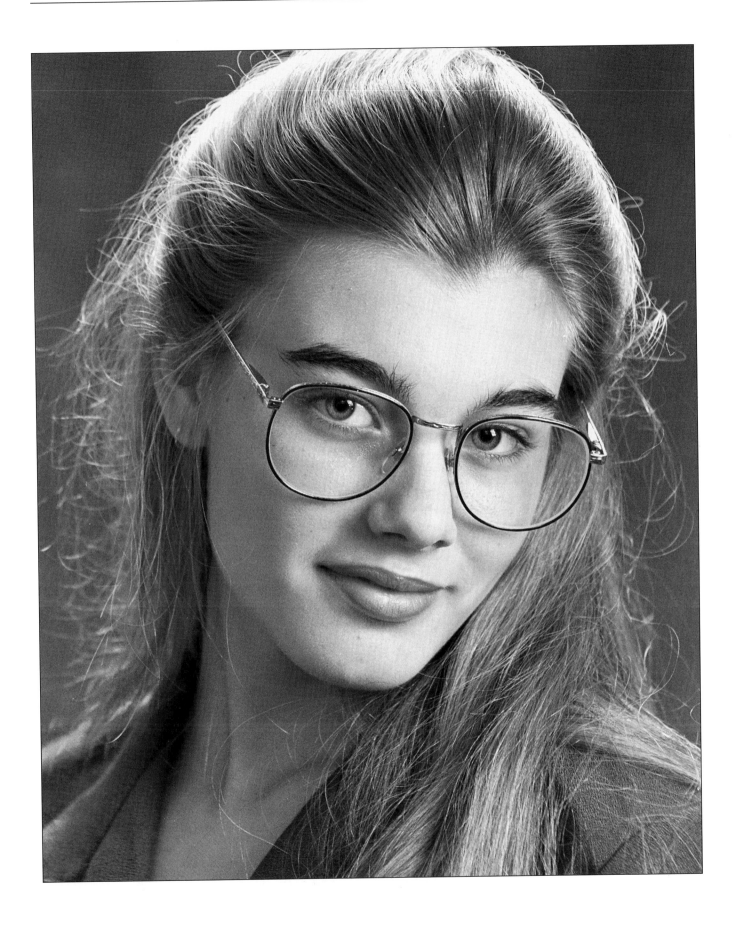

Location Lighting

When photographing on location in clients' homes, the goal is to produce the same lighting patterns as studio lighting. The same sculpting of features with the main light, control of shadow brightness from the fill light, control of the background intensity, and nice back lighting on the subject's hair all create a three dimensional feeling to the portrait.

"...the goal is to produce the same lighting patterns as studio lighting."

Location Lighting Indoors

Umbrellas are practical on location because they are more portable than soft boxes. A studio light unit in a 36" umbrella can be the main light, when placed to provide the lighting pattern desired. A powerful portable strobe mounted on a bracket that keeps the flash directly above the camera lens can be used as the fill light. Since this fill light must have fully variable intensity, you can create whatever fill ratio you desire. This flash unit is also the trigger light: it fires the other lights, which are all on slave triggers.

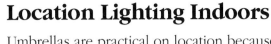

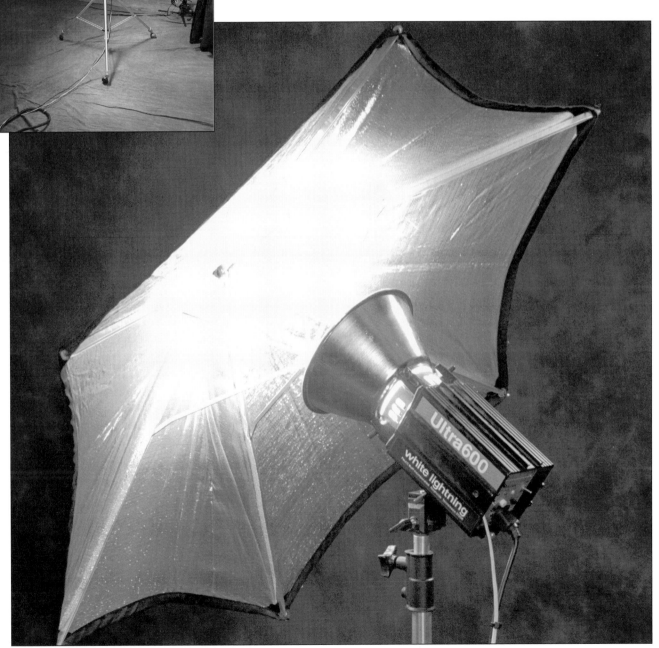

Place another studio light on a low stand (where needed) to provide small illumination of the background as determined by readings with the strobe meter.

It's difficult to use a "hair light" on location in people's homes: mounting the light overhead and not showing the light and stand in the picture are almost impossible tasks. You might use a bare light bulb hidden behind the group. This provides background light while giving some hair light from behind and below the subject.

Set the main light bouncing out of an umbrella for an exposure of $f8$, $f11$ if the group arrangement will be deep. Keep the group in one place as much as possible to keep everyone sharp. Measure the camera-to-subject distance accurately to be sure your depth of field will cover the depth of the pose. If you have enough light, set up for $f11$ exposure to gain the depth of field for a large group and to maintain some sharpness in the background of the room.

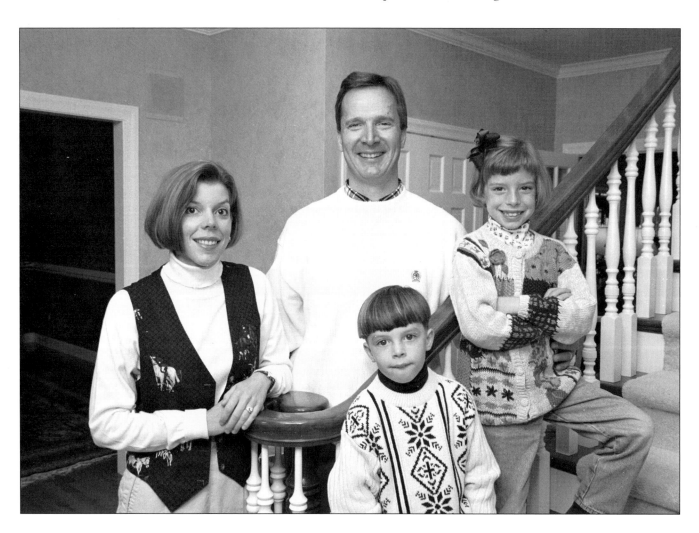

For weddings or other location photos, use a powerful variable strobe on a rotating bracket. This will keep the light above the lens in horizontal and vertical composition.

If you want noticeable shadows, set the fill light for an intensity of *f*4 (two stops less than the main light, for a ratio of 1:4). If you want fuller illumination in the shadows, set the fill for *f*5.6 (a ratio of 1:2, for barely noticeable shadows). Normally do not use shadows darker than 1:4 for a group portrait.

For a dark background, simply underexpose the film by one or two stops (read your main light with an incident flash meter of *f*4 or *f*5.6 intensity). If shooting at *f*8 and you want the background to be fully illuminated, set the background light intensity at *f*8.

Location Lighting Outdoors

Try to position your subjects so that the sun shines on their backs. Back lighting is beautiful outdoor lighting. You can photograph most outdoor portraits this way, from individuals to groups. You'll get fewer squinting eyes that way, beautiful lighting on the subjects' hair, and nice rim lighting on their bodies.

"You can photograph most outdoor portraits this way..."

The faces of these subjects are actually in shadow, but a flash illuminates them to the proper exposure.

Use a camera-mounted flash on a bracket that lets you rotate the camera, keeping the flash directly above the lens when the camera is in a vertical or horizontal position (the Newton bracket works well). To minimize shadows in this fill flash situation, keep the flash close to, and always above, the lens. The flash and bracket arrangement puts the flash about 10 inches above the lens. That's enough to eliminate red eyes and does not create any new shadows.

Below, a diffuser is added to the flash bracket for softer on-camera flash lighting.

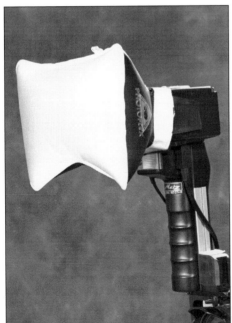

If the sun is bright, reading the light intensity off flesh tones will give you an exposure of $f11$ at 1/200th of a second (for professional portrait films rated at ISO 100). Since you are shooting into the light, the background of the subject will be the background light as well. And since it is shadowed, the background will be darker than full lighting. For bright highlights, shoot at $f8$ at 1/200th. We set the camera-mounted strobe on manual exposure to provide correct light for $f8$ at our shooting distance. This fully illuminates faces with brighter highlights on the hair, and creates rim light from behind with a slightly dark background.

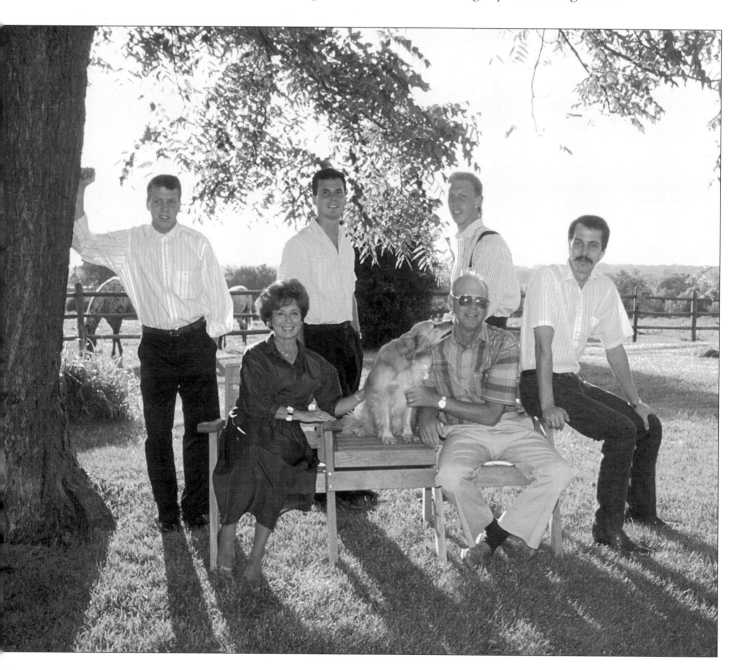

My rule: never photograph people without flash. Indoors or out. Sunny or overcast. Creative use of flash will always improve pictures of people. It doesn't have to look like flash was used, and actually, it's better if nobody can tell that flash was used. I just want highlights in people's eyes and good color in facial flesh tones.

Overcast light is unflattering in almost any situation. This is known as "down" light because it comes straight down from overhead. It creates dark eye sockets and deep shadows under cheeks. It also makes bald heads and white hair shine brightly. These are undesirable effects.

Here, the down light from an overcast sky is blocked by a gazebo. The family is illuminated by a flash above the camera lens.

Instead, shine horizontal light into the subject's face. When working with overcast light, try putting your subject under some overhanging leafy branches to block some of the overcast light. Putting them under an overhanging structure eliminates unflattering vertical light, and illuminates the faces with nice horizontal light. Some photographers use dark umbrellas or gobos to minimize overhead light, then use a bright reflector or flash to create some controllable horizontal light. This light is then directed into the subject's face to create the desired lighting effect.

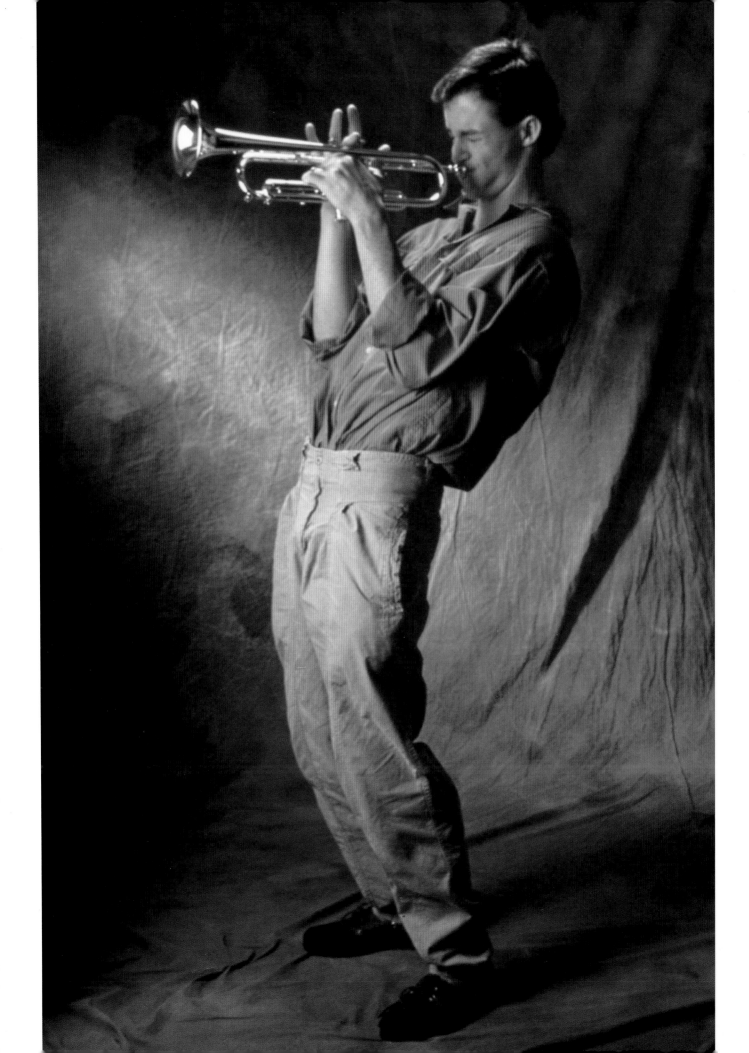

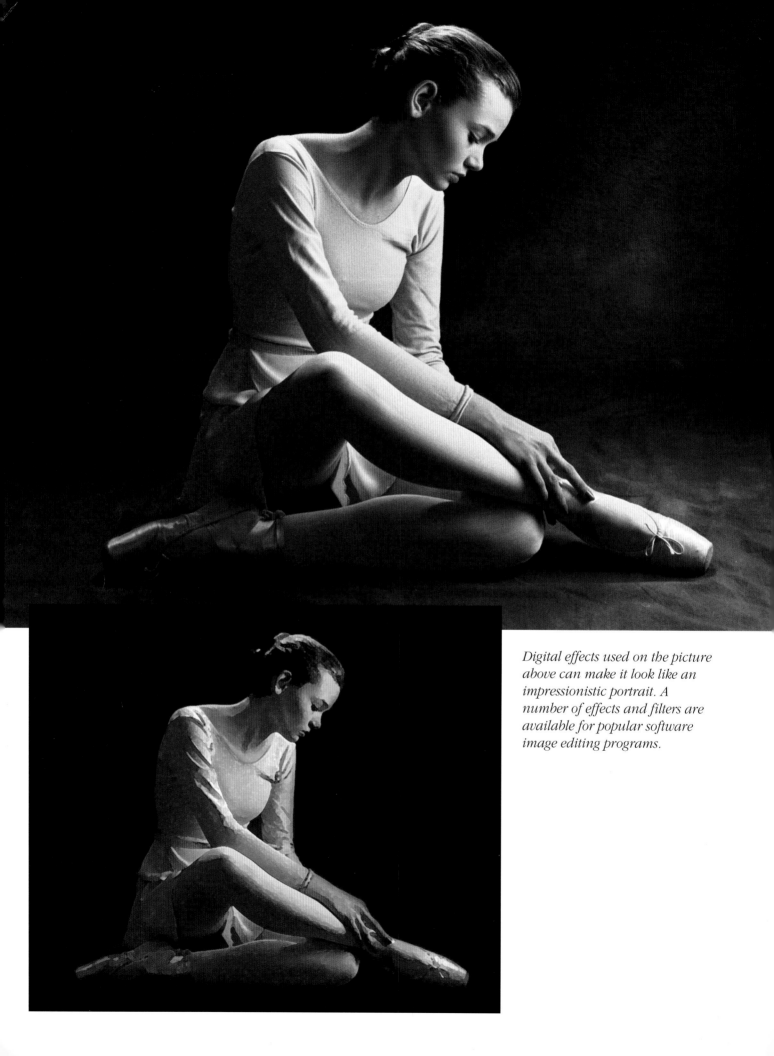

Digital effects used on the picture above can make it look like an impressionistic portrait. A number of effects and filters are available for popular software image editing programs.

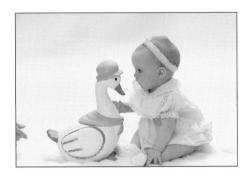

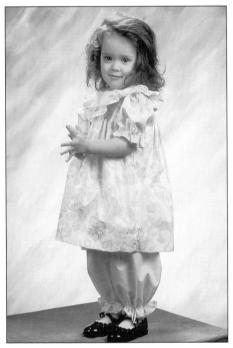

Subjects, Posing and Props

The "photography life cycle" is fundamental to a thriving portrait studio. Individual and group portraits can be made at any stage of life:

Babies	High school seniors
Toddlers	Wedding
Preschool children	Family groups
Elementary school children	

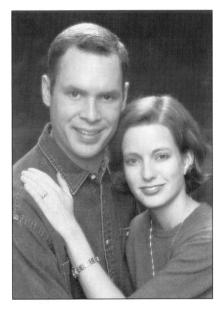

A large demand exists for good portraits of babies, toddlers and preschool children. Establishing a solid "photographer/client" relationship at these stages is crucial. If you do good, imaginative work, parents of school-aged children will do business with you in addition to the photographer contracted by the school.

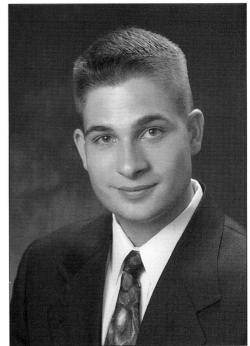

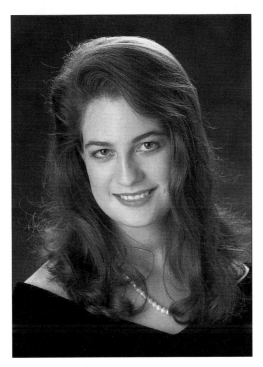

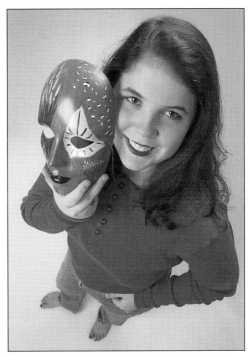

Photographing high school seniors is a portrait industry in itself. Graduating seniors come to portrait studios because they prefer imaginative portraits to the ones taken by the school photographer. Trading wallets with their friends is a tradition. Many parents create home portrait displays of their children as they graduate from high school.

Now is the time to suggest a family portrait. As you photograph seniors, you normally work with a mother — who sees her child as an adult for the first time in these portraits. Now that their children have grown up and will be going off to college, they should get a portrait taken of the entire family while the children are still at home.

These high school seniors will be getting married in a few years. If you establish good rapport with them now, they'll be customers for life. They'll return to you for wedding pictures — and give you the opportunity to become their family photographer when they have children of their own. Establishing and maintaining good client relationships makes you a partner in a family's photography life cycle.

Few families will call for a group portrait unless there is some encouragement. The best promotion of all is a large display of beautiful family portraits in your studio. Better yet, display some portraits in another business, a busy mall, a civic center, a restaurant, or anyplace where they will be seen by lots of prospects. It helps, too, if past customers are telling the world about your wonderful portraiture.

This portrait wasn't easy. Some of the children didn't cooperate, and the parents were stressed and distracted by the childrens' behavior. The finished portrait above was created in Adobe Photoshop using faces and bodies from different negatives taken during the session. In order to get the right poses and expressions, we used six negatives — and even took a shot of the tall fellow in the center over again. The final 24"x36" print was done digitally on canvas. We made digital negatives from the electronic file to make smaller prints.

Posing

Basic front-facing posing positions (plus hundreds of variations). work for close-ups, seated or standing, and group poses. You can also incorporate hands, props, or different backgrounds.

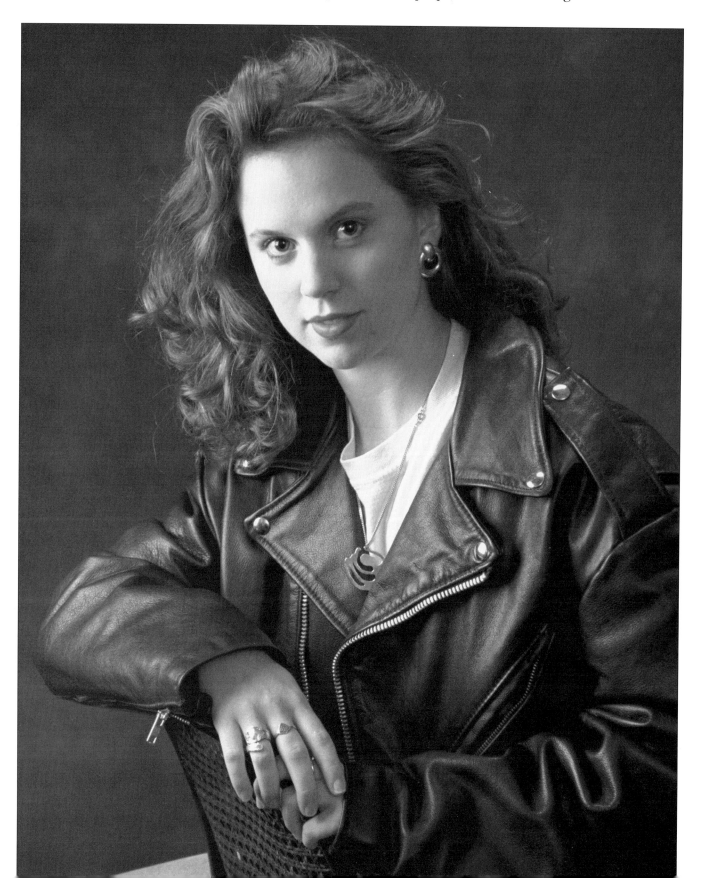

The best way to learn posing is to study portraits: photographs or great paintings, contemporary or traditional. Don't be afraid to try old-fashioned poses you find in famous paintings — most poses come back in style eventually. Creativity in portraits comes from finding dynamic ways to combine faces, hands, bodies, backgrounds and props.

Facial Expressions

Expressions are not all smiles. Some of the most beautiful portraits feature pensive subjects. No smile is better that a phony smile. And do not ask a subject to smile — a good photographer should cause the subject to smile. This is a valuable skill for a portrait photographer to have. Learn to make the subject feel good, so they will look good.

The ability to cause a subject to smile requires an uninhibited photographer: willing to become a child when photographing a child, willing to command a situation and control attention when photographing a large group of adults, and able to be sincerely flattering and complimentary with individual subjects.

A word of caution: there is a fine line between being flattering and being "fresh" when photographing attractive women. A male photographer could be misinterpreted when flattering a female subject. It is necessary to maintain a respectful distance and be careful of what you say. Learn to adjust poses and body positions through hand signals and examples rather than by touching. If you must touch a subject in posing, always ask first: "May I adjust your hair?" or "Can I position your face?" This may save potential problems.

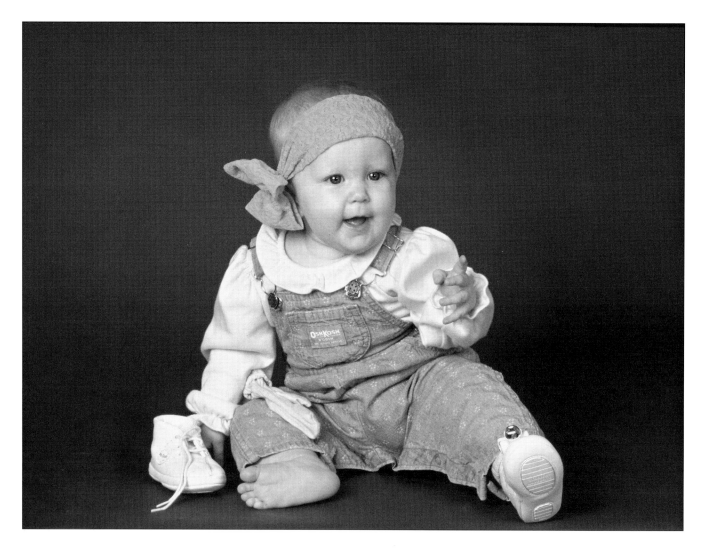

Photographing Children

When photographing children, short attention spans can be a problem. It won't help to tell them that they are cute or beautiful — they don't care. Instead, surprise them with a toy. We use a variety of hand puppets held in one hand, so an automatic focus camera can be operated with the other.

Our best attention-keeper for children is a soft foam ball (about 10 inches in diameter) made of strips of foam. This is fastened to a 5' elastic band and strapped to my left hand so that I can throw the ball toward the child and jerk it back just before it touches them. We even use this ball with large groups: it keeps the children watching us and even brings some smiles to the adults.

Remember to constantly update your techniques since you will get the same children back year after year.

Props and Accessories

You will need:

- Two adjustable posing stools for couples and small groups

- One or two (non-rocking) living room chairs for posing groups

- A set of 4 stacking boxes to adjust the height of subjects (also useful for seating children)

- A low table on wheels to pose children

- A posing bench on wheels is also useful for prop storage. You can cover this and other props with posing cloths from a local fabric store.

- An adjustable posing table: most people are more comfortable posing at a table than just sitting there not knowing what to do with their hands.

"...most people are more comfortable posing at a table..."

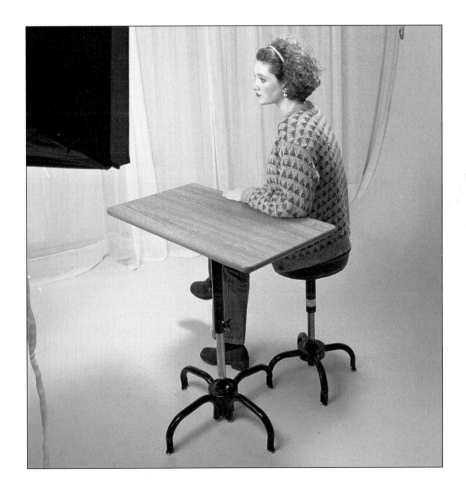

Furniture

Be sure to have a variety of furniture in your studio for photo props. Consider benches, as well as colored and leather chairs. Other props include feather boas, shirts, jackets, hats, children's toys, *etcetera*. For high school seniors, you need a black velvet "drape" which the girls wear to simulate an evening gown.

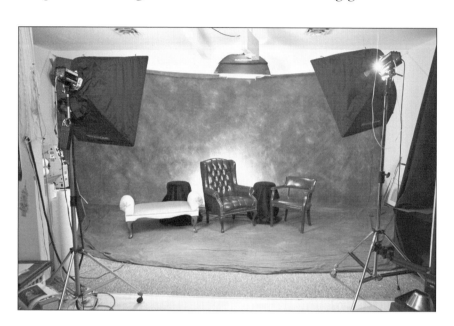

"Subjects gain confidence as they try different expressions in front of the mirror..."

A slim, full-length mirror on a movable stand makes a good "posing mirror." Subjects gain confidence as they try different expressions in front of the mirror before the shoot. But be sure to stand in front of the mirror or block it from their view while you shoot. Otherwise your subjects' eyes will wander as they watch themselves in the mirror.

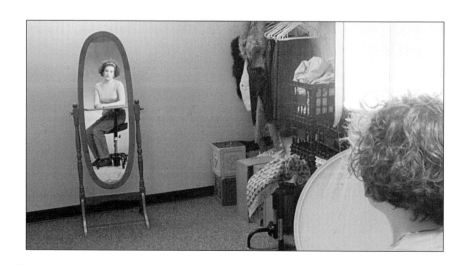

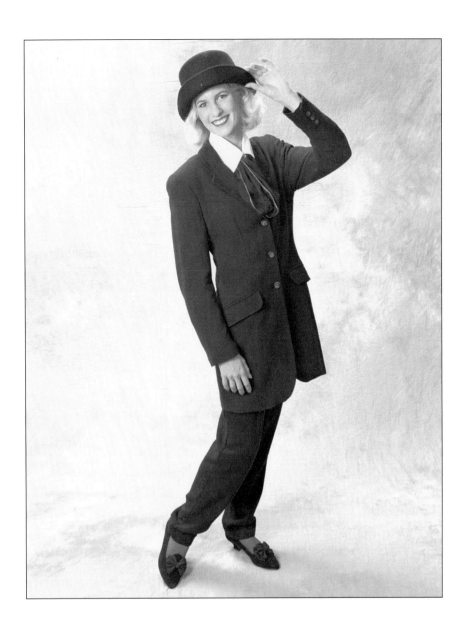

Backgrounds

Use painted muslin in 10' x 20' or 12' x 24' for backgrounds. Start with a mottled gray or old masters brown muslin. We secure the corners of the background to the ceiling with rope and pulleys, then spread the rest of the cloth over the floor towards the camera. Deliberately drape the muslin to create large folds and wrinkles.

When photographing large groups, use two identical backgrounds. Put one across the background (wrapped around the side walls of the camera room) and then put the identical background on the floor. Overlap them where the wall meets the floor. This creates space to photograph large family groups in a small camera room.

High-Key Backgrounds

White high-key backgrounds are popular, especially for children. White muslin wrinkles easily, however. Somehow, wrinkles look good on dark or colored backgrounds, but not on white. For a smooth high-key background, look for a pure white vinyl floor covering. This has a pattern on the top side, so put it up backwards (with the pattern down). Hang it high on the wall near the ceiling, so it hangs down and makes a smooth curve at the floor and extends towards the camera about 12 feet. This is easily cleaned with scouring pads since the material is made entirely of white vinyl.

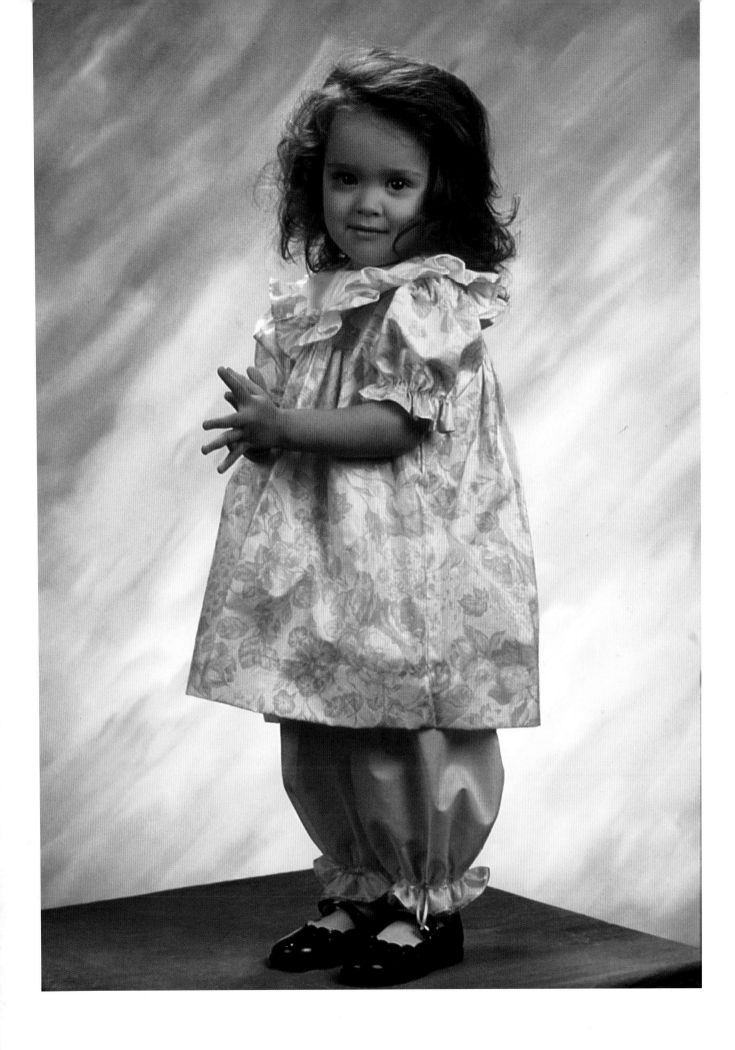

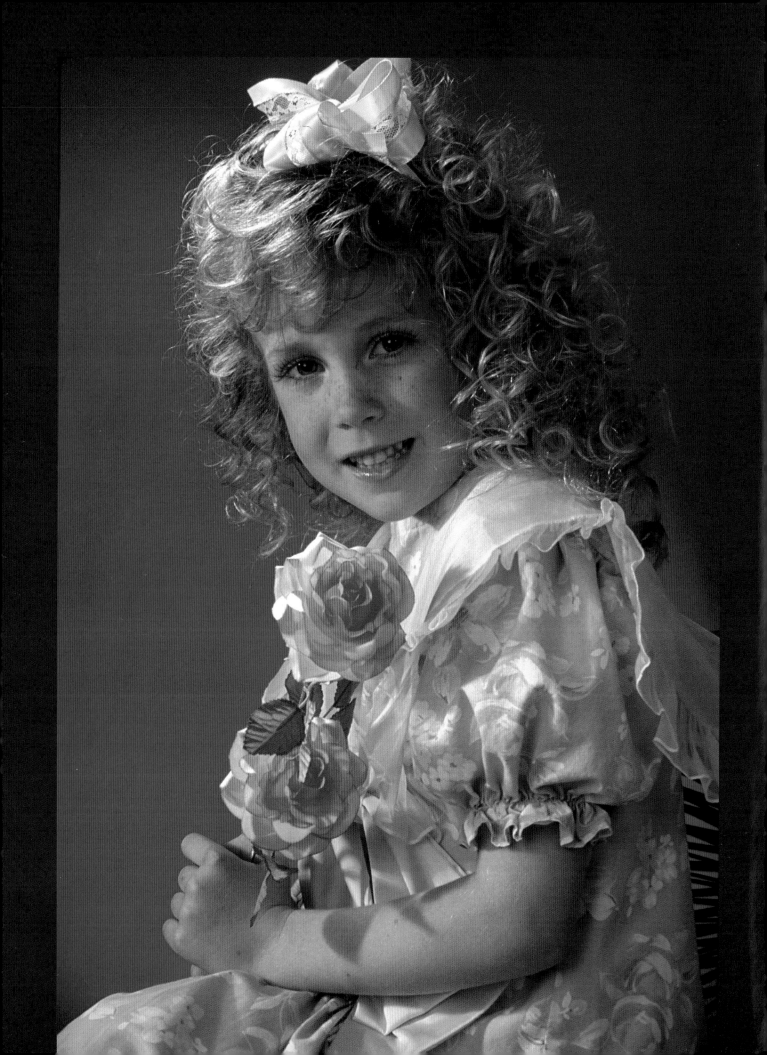

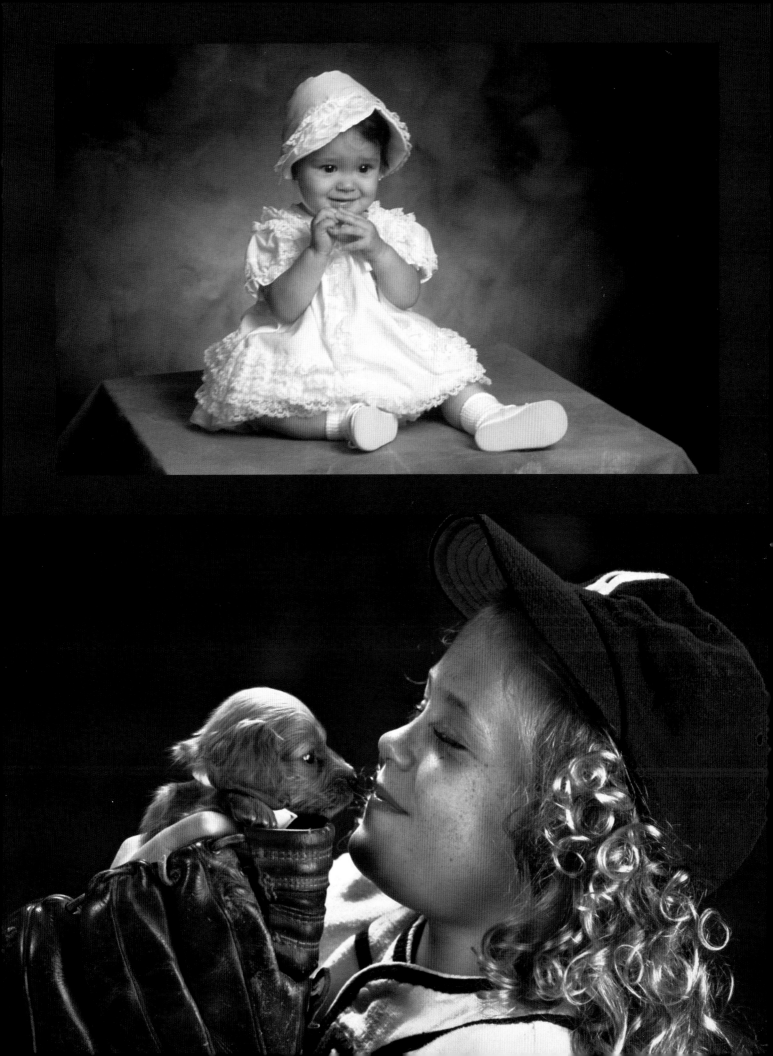

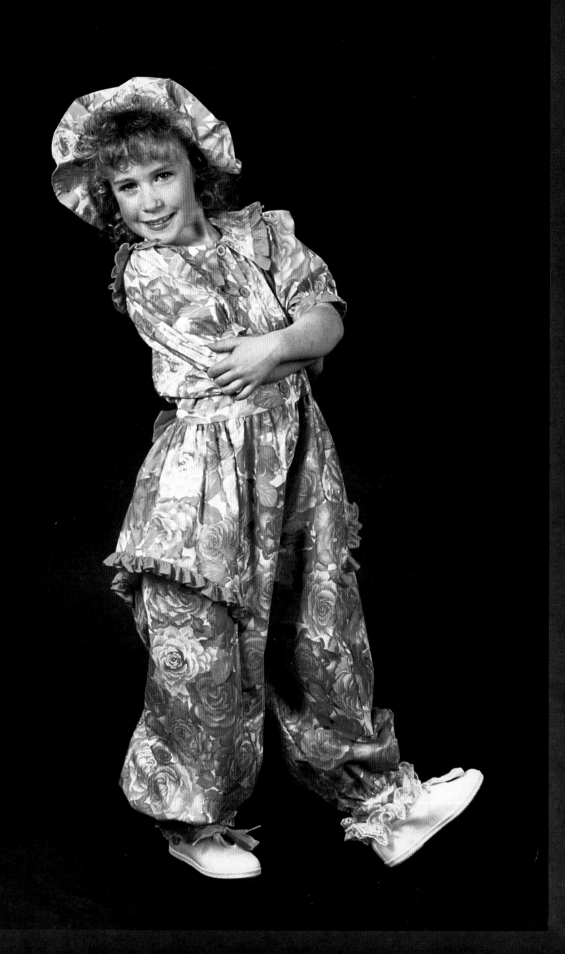

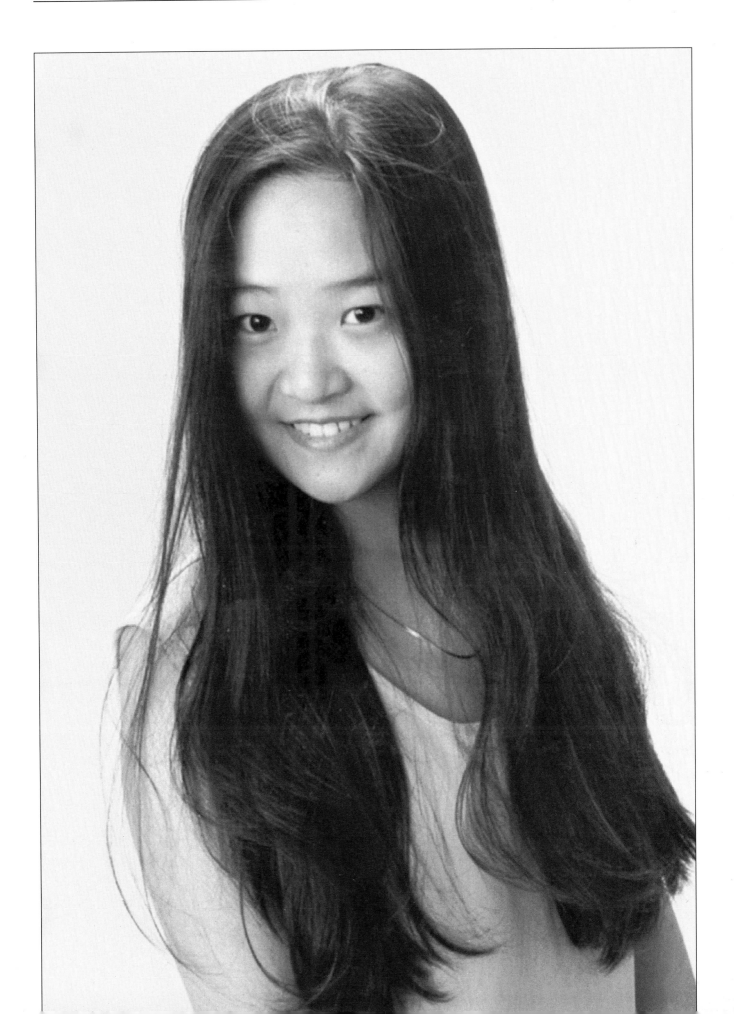

CHAPTER FIVE

Proof, Preview & Production

While it is possible to set up a small darkroom, develop your film, and make your prints using traditional wet processing, this is not very practical or efficient in today's automated world.

Traditional Proof Print Method

Most professional portrait photographers take the pictures and then send the film to a professional lab to be processed and have proof prints made. This means that customers wait several days or a week before they see the results. Because making proof prints costs money, most photographers have learned to take fewer pictures to control their costs, and show a limited number of proof prints to the client a week or more after the pictures were taken. Unfortunately, the subject may lose interest during this time.

According to a Photo Marketing Association 1993 survey, portrait customers had three complaints: not enough pictures were taken, it took too long to see the pictures, and they didn't get to keep the proofs. Solving these problems is the key to success in the portrait business.

Film Processing in the Studio

Take many pictures with inexpensive 35mm film (rolls of 36 exposures). Then process the film on the spot. Current color negative film process C-41 RA can be processed and dried in about ten minutes. This requires investing in an automatic machine. A machine

"The digital camera is an alternative that offers fast service without having to process film."

which doesn't dry the film will cost a bit less than a fully automatic one that does.

Immediate processing creates an opportunity to show the negatives on a television monitor by projecting them through a video viewer. The large-screen, high-quality "video preview" shows dozens of poses within ten minutes of taking the pictures. The customer gets a large selection — while they wait — and there are no proofs for them to covet (unless they order and pay for them in advance).

The digital camera is an alternative that offers fast service without having to process film. To make high-quality prints (up to 11"x14") requires a camera that produces a digital file of at least 10 to 15 MB. For larger prints, a camera that produces a larger file is required. These cameras also produce image files that can be printed on digital printers — a technique that approaches the image quality of traditional photography processes.

Printing Techniques

Most professional processing labs analyze your negatives on sophisticated video equipment to produce predictable, accurate color and density in pictures. But the more creative your pictures, the more difficult they are to print on the automatic lab equipment found in retail one-hour photo labs. For instance, a hi-key portrait ("white on white") is not easy to print. Their printer will make this much too dark, and the whites will be gray. A good operator will make some kind of adjustment to correct it. However, you will want more consistent results. Depending on the operator will yield different results every time.

How about a person dressed in black leather and posed on a black background? This shot is creative, but difficult to print. The printer will make this too light, and the blacks will be gray. (Again a skilled operator can make appropriate judgment corrections.) How about a portrait that uses a dominant color scheme, like a red background behind a person dressed in red? This will cause a cyan flesh tone in prints, requiring inconsistent operator intervention. It's possible to correct, but difficult to achieve the result envisioned by the photographer.

The solution is for the lab to print in "fixed time" or "locked beam mode" on the printer. The printer is set to print with certain fixed filtration and fixed exposure. For this to work, the photographer must create negatives that will always print correctly at this setting. The photographer must produce consistent negatives, and the lab must tightly control the printing process.

Exposure

The key to cost-effective portrait production is consistent exposure. Always use the same film, at the same exposure, and use a string on the main light to ensure accuracy. Set this up with a digital flash meter accurate to within 1/10th of an f-stop.

A good test is to shoot some studio portrait sittings on slide film Any slides that are not perfect would have been hard-to-print negatives. Sophisticated light meters make it unnecessary to bracket exposures. Instead, "bracket" expressions: shoot more pictures and coax different expressions from the subject.

"The key to cost-effective portrait production is consistent exposure."

No Proofs

Making proof prints lends itself to controversy with the customer. They want to take the prints home, and then it can be difficult to get the customer back to place an order. It's much simpler to use a video preview. Process the negatives and immediately show them on a 27" TV monitor. (Fuji, Sony and Tamron all make video preview devices.) There are no preview prints unless the customer orders them — and pays for them in advance.

Video Preview

Video Preview gives the one hour portrait advantage. Take the pictures and show them in 10 minutes! Accurate and economical, the only cost for a sitting is a roll of film and developing the negatives. Showing 16"x20" previews encourages the customer to buy larger prints.

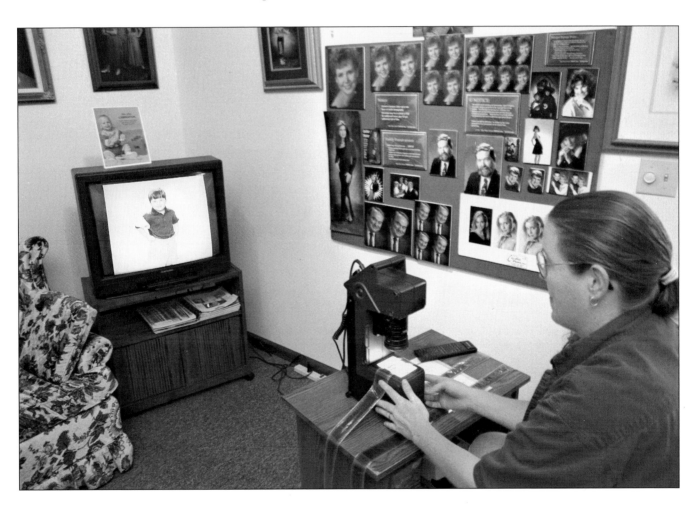

Retouching

Traditionally, portrait retouching is done by marking out blemishes on the negative with colored pencils, or skillfully applying colored dyes under a magnifying lens. This is possible only if the face on the negative is an inch or more in diameter. Therefore, corrections of this type are limited to cameras that produce large negatives.

Small 35mm negatives are difficult to retouch except on very tight close-ups. Most retouchers will not work on small negatives and limit their retouching to larger prints. Therefore, if your customer orders 100 wallet prints, they would each have to be retouched — on the prints, one at a time, at a prohibitive cost.

Some photographers prefer "pre-touching" subjects with make-up and powder. This can remedy problems before you take the pictures, but most states have cosmetology laws that restrict who can apply make-up. In such states, your studio needs to become a licensed beauty salon before you can apply make-up to customers.

Retouching with Digital Imaging

With digital image editing, a 35mm negative are scanned into the computer for easy retouching and manipulation of the photograph. When you use a digital camera, your image is already available for editing in the computer, making retouching a simple by-product of the photographic process.

"Digital retouching is photographic magic."

Digital retouching is photographic magic. Simple editing requires minimal skill. With slightly more advanced editing you can move faces from one negative to another, open eyes that are closed, change backgrounds, add people, or even remove someone from the image completely. The powerful options turn your computer into more than just a digital darkroom, and give the photographer nearly limitless photographic control of the appearance of an image from exposure, to the finished portrait.

Digital images can be printed to a new negative on 35mm, 120, or 4x5 film for printing by traditional methods, or the retouched image file can be printed directly on a photo digital printer. There are other options as well for adding type, or creating special effects.

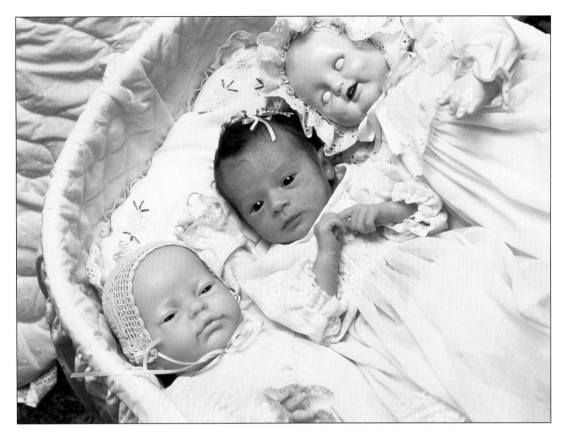

This image of a baby with antique dolls is transformed into triplets with the magic of digital retouching. A simple five minute procedure in the computer, this would be nearly impossible using traditional lab techniques and retouching.

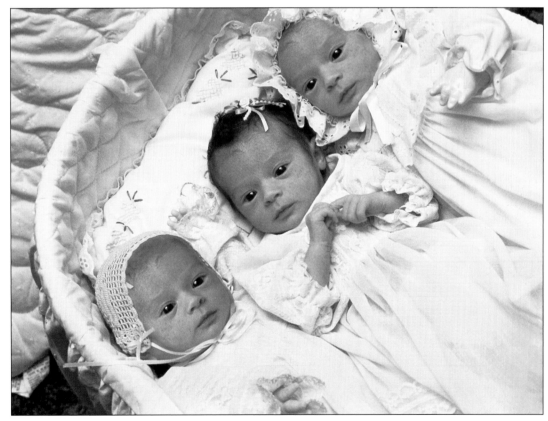

Chapter Six

The Business of Portrait Photography

"...they will want to spread the word and show the pictures to their friends."

Portrait customers are a loyal clientele. After you have produced beautiful portraits for them, they will want to spread the word and show the pictures to their friends. Satisfied customers are good advertisers. Portrait photography is a "word of mouth" growth business.

Pricing Portraits

When pricing your portraits and packages, do not adopt a price schedule that is too low. Low prices will attract clientele that will purchase few pictures. By charging an appropriate price for beautiful work, you will improve your studio's clientele and attract customers that will purchase more and larger prints — and bring more business back to you. If you want more printing volume in your lab, try a lower price on larger quantity print packages. If you send your printing out, you might price higher and make more money with less work.

Your primary goal is to create beautiful portraits. There is no price low enough to sell an unflattering portrait to anyone. If you produce truly striking portraits that your customers value, there is almost no price that is too high. Be aware of your local competition and their pricing, but also be aware of the differences in services.

Three Profit Opportunities

1. Charge a sitting fee for the portrait session. It pays for your time, the film, and perhaps a video preview or showing of proof prints. No pictures are included.

2. A video preview makes paper proof prints unnecessary. Offer preview prints at a low price and present at least 24 of them in an album. Since the customer pays for the proofs, they get to take them home. Collect payment for the sitting fee and preview album when you take the pictures.

3. Price photo packages in convenient unit sizes for your production. For example, using an 8"x10" unit size, two identical 5"x7"s would be one unit, an 11"x14" is 2 units, *etcetera*. The unit is priced high enough to justify the set-up and printing charges. Additional units ordered at that time should be priced lower to encourage larger orders. Keeping the print price low discourages customers from having prints copied elsewhere.

Selling Portraits

Professional sales training will help you sell more pictures at a better price. Beautiful portraits are an emotional product, an impulsive sale. Offer the proper sales environment, a good professional salesperson (on commission) and adequate time for selling. You make more money in your sales presentation area than you do in your studio or in your lab. Portraits are not a "self service" item; they have to be sold. Most people are too shy to admit that their pictures look terrific — you have to tell them and assist them in making their purchase decisions.

Packaging

A quality product needs quality packaging. When you produce a beautiful family heirloom, don't put it into a plain brown bag. Consider the total product presentation, including paper, frames, matting and the packaging for transportation.

Hiring a Photographer

Technical skill is less important than personality in chosing a photographer. The technical person tends to get bogged down in

technical things. Great portraits are made with the simple techniques, and a great personality. A love for people is much more important than a love for photo equipment. It's much easier to teach a charming person photography than it is to give lessons to a technical introvert on how to be charming. An outgoing person who can stimulate conversation, who can talk to strangers and children easily, and who is quick with compliments is a strong candidate to become a portrait studio photographer.

"This business is potentially so profitable that you can afford to pay good employees what they are worth."

Compensation

Once you get a good photographer, you need to pay them well to keep them. You might adopt a commission system that lets a good photographer/salesperson share the rewards of this enterprise. A fair compensation system will go a long way towards keeping good photographers on your staff instead of seeing them become your competition. This business is potentially so profitable that you can afford to pay good employees what they are worth.

One Hour Portrait Studio Facility

Think in terms of profit per square foot. You can photograph babies and children individually in a small space of about 6'x8'. The real potential comes with more space. Couples, small family groups and more variety in poses and props all become possible with a 10'x20' room. This also gives you room enough to light the background creatively. Large family groups may need a room of up to 20' wide with at least 20' of shooting distance. An efficient studio set-up makes money.

A high ceiling is desirable: 10' to 12'. You must be able to light from above, even when photographing a standing adult. With an 8' ceiling, you cannot stand adults and light them properly.

Camera Room Lighting

The camera room should be illuminated only by the strobe modeling lights so you can see the effect of the lights on your subject. Have electrical provision for flipping one switch to turn on and off all of your studio lights at the entrance to the studio. You need minimal other light in the camera room — you should be able to switch it off when you are using your studio lighting.

Camera Room Design Tips:

- Using a room with no windows makes it possible to control all of the light in the room.

- Your camera room should be completely dark except for the studio lights.

- The room should be private. An audience makes it difficult for your subject to perform.

- Use hard commercial carpet on the floor, and cover it with muslin background.

- Consider painting backgrounds on both end walls of the camera room, or use a white seamless vinyl background.

- Avoid outlets, doors, or windows on the end walls of the studio if you plan to use it as a painted background. These will distract from the scene.

Customer Dressing Room

A large, comfortable dressing room equipped with a sink and rest room facility is desirable. The dressing room should be spacious, clean, neat and well-lit. Before allowing staff to help with make-up application, check legal restrictions in your state. A cosmetologist's license may be required.

A separate waiting and sales room with comfortable accommodations for large groups pays off, if you can afford the space. You might combine this with your display/lobby area, where customers see samples of your work before their portrait session. Furnish the room comfortably, with couches and several "living room" style chairs. Create a place where your customers feel welcome and at ease. Display lots of beautiful portraits — nothing will help promote your business more.

"Create a place where your customers feel welcome and at ease."

Index

Other Books from Amherst Media, Inc.

Basic 35mm Photo Guide
Craig Alesse

Great for beginning photographers! Designed to teach 35mm basics step-by-step — completely illustrated. Features the latest cameras. Includes: 35mm automatic and semi-automatic cameras, camera handling, *f*-stops, shutter speeds, and more! $12.95 list, 9x8, 112p, 178 photos, order no. 1051.

Infrared Photography Handbook
Laurie White

Covers black and white infrared photography: focus, lenses, film loading, film speed rating, heat sensitivity, batch testing, paper stocks, and filters. Black & white photos illustrate how IR film reacts in portrait, landscape, and architectural photography. $24.95 list, 8½x11, 104p, 50 b&w photos, charts & diagrams, order no. 1419.

Build Your Own Home Darkroom
Lista Duren & Will McDonald

This classic book shows how to build a high quality, inexpensive darkroom in your basement, spare room, or almost anywhere. Information on: darkroom design, woodworking, tools, and more! $17.95 list, 8½x11, 160p, order no. 1092.

Into Your Darkroom Step-by-Step
Dennis P. Curtin

The ideal beginning darkroom guide. Easy to follow and fully illustrated each step of the way. Information on: equipment you'll need, set-up, making proof sheets and much more! $17.95 list, 8½x11, 90p, hundreds of photos, order no. 1093.

Wedding Photographer's Handbook
Robert and Sheila Hurth

The complete step-by-step guide to succeeding in the exciting and profitable world of wedding photography. Packed with shooting tips, equipment lists, must-get photo lists, business strategies, and much more! $24.95 list, 8½x11, 176p, index, b&w and color photos, diagrams, order no. 1485.

Lighting for People Photography
Stephen Crain

The complete guide to lighting. Includes: set-ups, equipment information, how to control strobe and natural lighting, and much more! Features diagrams, illustrations, and exercises for practicing the lighting techniques discussed in each chapter. $29.95 list, 8½x11, 112p, b&w and color photos, glossary, index, order no. 1296.

Camera Maintenance & Repair
Thomas Tomosy

A step-by-step, fully illustrated guide by a master camera repair technician. Sections include: testing camera functions, general maintenance, basic tools needed and where to get them, basic repairs for accessories, camera electronics, plus "quick tips" for maintenance and more! $24.95 list, 8½x11, 176p, order no. 1158.

Camera Maintenance & Repair Book 2
Thomas Tomosy

Build on the basics covered in the first book, with advanced troubleshooting and repair. Includes; mechanical and electronic SLRs, zoom lenses, medium format cameras, troubleshooting, repairing plastic and metal parts, and more. Features models not included in the first book. $29.95 list, 8½x11, 176p, 150+ photos, charts, tables, appendices, index, glossary, order no. 1558.

Wide-Angle Lens Photography

Joseph Paduano

For everyone with a wide-angle lens or those who want one! Includes: taking exciting travel photos, creating wild special effects, using distortion for powerful images, and much more! Part of the Amherst Media's Photo-Imaging Series. $15.95 list, 7x10, 112p, glossary, index, appendices, b&w and color photos, order no. 1480.

Big Bucks Selling Your Photography

Cliff Hollenbeck

A complete photo business package for all photographers. Includes secrets to making big bucks, starting up, getting paid the right price, and creating successful portfolios! Features setting financial, marketing and creative goals. This book will help to organize business planning, bookkeeping, and taxes. $15.95 list, 6x9, 336p, order no. 1177.

Great Travel Photography

Cliff and Nancy Hollenbeck

Learn how to capture great travel photos from the Travel Photographer of the Year! Includes helpful travel and safety tips, equipment checklists, and much more! Packed full of photo examples from all over the world! Part of the Amherst Media's Photo-Imaging Series. $15.95 list, 7x10, 112p, b&w and color photos, index, glossary, appendices, order no. 1494.

Telephoto Lens Photography

Rob Sheppard

A complete guide for telephoto lenses! This book shows you how to take great wildlife photos, portraits, sports and action shots, travel pics, and much more! Features over 100 photographic examples. $17.95 list, 8½x11, 112p, b&w and color photos, index, glossary, appendices, order no. 1606.

Restoring Classic & Collectible Cameras

Thomas Tomosy

A must for camera buffs and collectors! Clear, step-by-step instructions show how to restore a classic or vintage camera. Work on leather, brass and wood to completely restore your valuable collectibles. $34.95 list, 8½x11, 128p, b&w photos and illustrations, glossary, index, order no. 1613.

Handcoloring Photographs Step-by-Step

Sandra Laird & Carey Chambers

Learn to handcolor photographs step-by-step with the new standard handcoloring reference. Covers a variety of coloring media. Includes colorful photographic examples. $29.95 list, 8½x11, 112p, 100+ color and b&w photos, order no. 1543.

Special Effects Photography Handbook

Elinor Stecker Orel

Create magic on film with special effects! Little or no additional equipment required, use things you probably have around the house. Step-by-step instructions guide you through each effect. $29.95 list, 8½x11, 112p, 80+ color and b&w photos, index, glossary, order no. 1614.

McBroom's Camera Bluebook

Mike McBroom

Comprehensive, fully illustrated, with price information on: 35mm cameras, medium & large format cameras, exposure meters, strobes and accessories. Pricing info based on equipment condition. A must for any camera buyer, dealer, or collector! $34.95 list, 8½x11, 224p, 75+ photos, order no. 1263.

Swimsuit Model Photography
Cliff Hollenbeck

The complete guide to the business of swimsuit model photography. Includes: finding models, selecting equipment, working with models, posing, using props and backgrounds, and much more! By the author of *Big Bucks Selling Your Photography* and *Great travel Photography*. $29.95 list, 8½x11, 112p, over 100 b&w and color photos, index, order no. 1605.

Achieving the Ultimate Image
Ernst Wildi

Ernst Wildi shows how any photographer can take world class photos and achieve the ultimate image. Features: exposure and metering, the Zone System, composition, evaluating an image, and much more! $29.95 list, 8½x11, 128p, 120 B&W and color photos, index, order no. 1628.

Black & White Portrait Photography
Helen Boursier

Make money with B&W portrait photography. Learn from top B&W shooters! Studio and location techniques, with tips on preparing your subjects, selecting settings and wardrobe, lab techniques, and more! $29.95 list, 8½x11, 128p, 130+ photos, index, order no. 1626.

Profitable Portrait Photography
Roger Berg

Learn to profit in the portrait photography business! Improves studio methods, shows lighting techniques and posing, and tells how to get the best shot in the least amount of time. A step-by-step guide to making money. $29.95 list, 8½x11, 104p, 120+ B&W and color photos, index, order no. 1570.

Camcorder Business
Mick and George A. Gyure

Make money with your camcorder! This book covers everything you need to start a successful business using your camcorder. Includes: editing, mixing sound, dubbing, technical and business tips, and much more! Also features information on covering a wedding or other special event for a client, legal and industrial videos, and more. $17.95 list, 7x10, 256p, order no. 1496.

The Art of Infrared Photography / 4th Edition
Joe Paduano

A practical, comprehensive guide to the art of infrared photography. Tells what to expect and how to control results. Includes: anticipating effects, color infrared, digital infrared, using filters, focusing, developing, printing, handcoloring, toning, and more! $29.95 list, 8½x11, 112p, order no. 1052.

The Wildlife Photographer's Field Manual
Joe McDonald

The complete reference for every wildlife photographer. A practical, comprehensive, easy-to-read guide with useful information, including: the right equipment and accessories, field shooting, lighting, focusing techniques, and more! Features special sections on insects, reptiles, birds, mammals and more! $14.95 list, 6x9, 200p, order no. 1005.